To Christina,

Thank you so much for all the ways you have encouraged me in this ministry.

Blessings as you continue to pursue a gloriously beautiful life!

Cari

A GLORIOUS
BECOMING

EMBRACE YOUR ROYALTY

CARI TROTTER

CROSSBOOKS
PUBLISHING

CrossBooks™
A Division of LifeWay
1663 Liberty Drive
Bloomington, IN 47403
www.crossbooks.com
Phone: 1-866-879-0502

First published by CrossBooks 07/13/2012

ISBN: 978-1-4627-1904-4 (sc)
ISBN: 978-1-4627-1905-1 (e)

Library of Congress Control Number: 2012912778

Printed in the United States of America

This book is printed on acid-free paper.

Dedicated to my Toby and our three sharp arrows

The bride, the beautiful princess, a royal daughter, is glorious. She waits within her chamber, dressed in a gown woven with gold. Wearing the finest garments, she is brought to the King. Her friends, her companions, follow her into the royal palace. What a joyful, enthusiastic, excited procession as they enter the palace! She comes before her King, who is wild for her!

Psalm 45:13-15

Contents

FOREWORD

When one thinks of a prime place for a suitor to take the King's daughter, the Great State Fair of Oklahoma does not automatically come to mind. Needless to say, that's where the King's daughter was with me in the fall of 2001. My master plan of deception was working. She had been on six months of dates with me, and I had made her laugh so hard to force sudden restroom breaks, so I was well on my way to pulling the wool completely over this girl's eyes.

How do you finish off a night at the state fair you might ask? Silver dollar cinnamon rolls by the space needle, and if you say otherwise, you are a filthy liar. I mean, we already crushed a gyro, Indian taco, and some chocolate-covered bananas and thankfully not bought in to the fried Snickers or fried bacon. There was only one thing left to do ... stand there while the dude with the handlebar mustache puts nineteen sticks of butter on the dough you will put into your mouth in fewer than ten minutes.

So I waited in line, gazing into the King's daughter's eyes and bought two cinnamon rolls and two milks ... big spender.

She went silent. My mind said, *Oh man, does she think I think she's fat and can handle her own cinnamon roll and has to wash it down with another vat of dairy calories? Am I fat? Why am I here? Is she about to pull the "friend zone" card? Shoot.*

The words out of her mouth were not anything near that retort. "You mean … I get my own?"

Going with the whole "just go with it" theory, I said, "Yeah, of course, you get your own." Now to the defense of my mother-in-law and father-in-law, they are awesome, loving parents, and Cari was not deprived growing up, always had shoes on, was bathed regularly, and reared with much care. And to my knowledge, she never ran around in the front yard in a diaper with dirt all over her face while the neighbors cataloged all. But tonight was different. Being the only non-boy of four kids, "getting your own" was just not common. Any kids with brothers and sisters know that sharing happens … it has to. But tonight, it was the first taste of her new reality. I don't think she was ready for it. It wasn't a big deal to me and all the entitled bones in my body, but it was to her.

Who would have known a $4.50 cinnamon roll had the significance of Kate Middleton walking into the Tower of London and seeing the Crown jewels for the first time, or having Prince William lay out all the opulent options for their honeymoon. Yes, those dreams were really starting to transform into reality. For her, this was just a taste of what she'd waited for all those years, and the first time I realized it, too, at the state fair, over baked butter and a plastic cup of 2 percent milk.

Well, the fruition of that realization is what you are reading today. That King's daughter came to me not two months later, in tears, expressing an inexpressible calling that had been dropped on her by the Holy Spirit to reach a generation. She had no idea what it meant, how it would develop, or what to do. All she knew was the King had spoken, and she answered His call.

Ten years later, *A Glorious Becoming* sits in your hand as you read. You may be sixty-five years old and still yearning for your cinnamon roll experience. This may be your first time fully realizing, "I get my own? This life is for me? You desire this calling for me? You want me to live in this palace? Eat this food? Put this jewelry on? This isn't borrowed? I don't have to pass an exam on etiquette? You really don't care about who I was? This ministry and these people are for me to pour your love on?" I know it's a lot, but you better get used to it, because this book is a B-17 that will continue to drop promise explosions all over your reality of despair.

I'm just a dumb football coach, but you still have to listen to me, because I'm married to the author and I'm the one writing this foreword. I beseech you (to borrow some old King James verbiage) to prepare your heart to realize its worth in the Kingdom, to realize your inheritance in love, and be blown away at how that realization will change your husband, children, calling, passion, and position. It's nothing new; there is no new King, no new Bible, no new promises, no new addendum to his perfect Grace that has been unchanged before the foundation of time. It's just that it may be new to you, because you have gone long enough

without gladly accepting your own cinnamon roll and milk. It's time a generation of daughters of all ages realizes its worth from within and operates in that queenly authority in every aspect of their worlds. The world is at Kate Middleton's hand, and she now has the freedom to let her spirit roam and land on whatever her heart says is important … and then extend unlimited monetary and influential resources to it all at once and see it change. You are no different. This book is written to remind you that you've been given the green light by the Holy Spirit as the King's daughter to find the worth that brings you alive, and demolish your calling and the needs that surround it with the overwhelming resources of the Kingdom.

This book is only one of the mahogany offices in a thousand-room palace, and Glorious Daughters will not rest until every woman fully realizes the scope and influence of her life as a daughter of the King. Enjoy the book, and enjoy being used as the voice of the King.

Toby Trotter

ACKNOWLEDGMENTS

To my Toby—my coach man—thank you for choosing me. Thanks for loving Jesus more than you love me. Thanks for listening to me read, re-read, and then re-read again just for good measure every sentence typed in this book. Thanks for being exceedingly patient, as I wrestled through every thought, emotion, and sleepless night writing this book required of me. Thanks for pushing me much farther than I ever thought I could go. Thanks for reminding me over and over again that obedience is better than sacrifice. Thank you for believing and pursuing an Ephesians 3:14-20 life for our family with a Joshua 1:9 kind of courage. I'm really glad you took me to the fair ten years ago and bought me my own cinnamon roll and plastic cup of 2 percent. I definitely married my tall, dark, and handsome Prince Charming. I love you.

To my three sharp arrows—Cade, Ainsley, and Shelby—you are a most precious grace offering from the King. Every day you are the ones who hold me accountable and push me on. Although you are small now, someday you will read

this, and I want you to know what a huge part you played in accomplishing a Kingdom work. I cherish you. Thank you for being patient. And thank you for reminding me of God's extravagant love every day. God's promise over your lives is that you will not only survive this world, but you, my sweet angels, will change it. I'm so proud of you … and yes … Mommy is having happy tears right now.

To all my family—thank you is a very small expression for the largeness of the meaning. The legacy of faith you have walked before and alongside me is the richest of blessings. Thank you for supporting me, loving me, praying for me, inspiring me, and encouraging me. Thank you for believing in me. With all my heart, I love you.

To my King, my Jesus, my Savior—You are my complete and total victory. Thank you for choosing to love me. Thank you for choosing to rescue me. Thank you for seeing me … all of me … past, present, and future and still using me. I am humbled by your offering. Thank you for being real in my life. Thank you for recklessly pursuing me every day. Thank you for chasing me down and never leaving or forsaking me, even when I have been less than easy to love. It is my joy to serve my King as a daughter, becoming all glorious within. I love you.

INTRODUCTION

As a family, we love a good throwback Sunday afternoon drive. Just driving around, going nowhere particular, just driving. Last night was one of those nights. We piled in the car, grabbed a snow cone, and started driving. Because we live out in the country, there is always plenty of driving to be done. The kids love to count the cows and horses we see as we meander down new county roads and see where they go. The time is usually spent dreaming about building a house while we listen to good-quality tunes, and every once in a while, we come to a place worth stopping.

In a smaller town, there aren't too many housing additions. In the process of our dreaming a little about a new house, we naturally have begun looking for the perfect lot. Nothing too vast, but we definitely want enough space so you feel like you could stretch out. We've come across several we like, but nothing we are just living and dying for … yet.

One night as we were driving, we saw a sign we hadn't seen before. It was advertising a brand-new addition in a

development. Worth checking out. So we came to a white picket fence and wrought iron gate indicating a new housing development was going to be built. We were intrigued. As we made the turn onto the gravel road, we noticed electrical boxes positioned at what would be each individual lot. We could see darling streetlights and even a quaint little pond and bridge in the middle of what seemed to be the clearing for a commons area of some sort. We drove on. This has potential. We drove to the back of the section of land and saw a great lot. Although uncleared and still very rugged, we could see its potential. We could see a vision for a very sweet place to build a house. We said to ourselves, "This could have real promise." It is out, but not too far out; it seems like you could still have community, and they are really moving on this project. Because it didn't seem any of the lots had been taken, we reasoned they must be in an early enough place in the development that we could get any lot we wanted. But we were just as sure that we needed to move fast. So we hustled back to the front of the addition to grab the number to call, thinking, *If this is a good deal, we'll want to jump on it so we can land the best lot!* This could become something really special.

Ring … ring … ring … "Oh hello. Uh, yeah, I know the lots you're talking about. No, it's actually been sitting there for going on two and a half years now. Just slow getting started and selling the lots, you know. I don't have anything in front of me right now. You'd be welcome to look if you want, but again, we're just moving kind of slow."

The buildup and hype we had created didn't match the action. Here's the thing: until someone starts either buying

those lots or gets real fired up about selling those lots and then creating a neighborhood, there is no "becoming." What is set up to achieve a great housing addition could very well remain just that ... a whole lot of potential but not a lot of becoming. We drove away disappointed, because we felt it would probably continue to be just what we saw: a carved-out gravel road, darling streetlights, a quaint pond with a bridge, and electrical boxes set on a rugged countryside and no houses. Potential. Until someone buys the lots, there would be no becoming of anything.

The same is true in our lives. Until we start buying in to the truth that the King holds our lot secure and start living as a daughter that is all glorious within it will remain potential. There will be no becoming.

I am a developer by nature. I see the "could be great" in everything, and I want so badly to see it come to its full God-given potential. It's what energizes me—fuels me, really. That is what I see in the ministry of Glorious Daughters and the potential of the daughters of God in this generation. I see the potential we have not to just hear the Word of God by default but intentionally and purposefully hear, receive, perceive, understand, be empowered by, and energized to not just survive this world but to change it. I envision generations of daughters that build lives on and see others healed, redeemed, persuaded, and held together by the power of the inspired Word of the King. I see our great potential to know the King so intimately we can arise and do battle in the dark of our circumstances, because we know in our deepest depths the King will fight for us. Our

boundary lines have been drawn in perfect places to impact a generation for God. As beautiful daughters of the King, we have been perfectly fashioned and brilliantly established to be leaders in our spheres of influence and produce an incredible harvest.

But until we start believing and operating out of the Truth of Psalms 16:5-6 and 45:13, there will be no becoming.

> The Lord is my chosen portion and my cup; you hold my lot. The lines have fallen for me in pleasant places; indeed, I have a beautiful inheritance. (Psalm 16:5-6)[1]

> The King's daughter is all glorious within. (Psalm 45:13)[2]

The book you hold in your hands is a project the Lord started with me many years ago. To have come to a place where I finally bought the lot and started plowing the land and building a "house" of sorts is energizing. However, I am reminded this morning, the true step toward becoming all glorious within has only just begun. I have to keep buying and cultivating new property in order to create worthwhile living space. So really, my becoming has just started.

Are you ready to stretch out and start becoming?

1

ECOMING

ıy hair day, the one moment I have to
myself at the salon. My one moment
for an hour. At times, it seems I
vy machinery of a coaching family
brain. I stand at the window in my
ıe snowfall and listening to the sleet
ıless street. As I stand there stoic and
penetrate to the depths of my heart.
on the western plains of Oklahoma.
My hair appointment is an hour away,
and aside from me buying a monster truck, my meticulously
planned cerebral checkout moment isn't happening today.

I close the blinds and walk into the kitchen to realize that
the grocery store elves were obviously shut in as well, and we
have no food for the troops. It is still early on this Saturday
morning, and no one is up just yet. The only sounds are
the unrelenting sleet slapping against the solid rock ground
and the shuffle of my slippers against the wood floors in my
kitchen. Going to Walmart looks like the adventure of the

day. I hate the emotions I am having, and yet somehow, I can't stop them from raising their ugly little heads. It feels kind of like that game you play at Chuck E. Cheese, the one where the gophers keep coming up, you try to knock them down, and they just pop up again. My emotions are the gophers that won't go away.

I dress warmly for the blizzard outside, and coffee in hand—coffee is always in hand—I open the door to the garage. In the deep recesses of my soul, I wish the doorknob I was reaching for belonged to the door to the wardrobe opening to more than just the winter wind that blows across your face like the sharp edge of a knife. More than just the sight of my white "taxicab" Suburban. There was no Learjet waiting to whisk me off on some whirlwind tour. No limo was idling, with door open, waiting to race me to a high society charity event. No champagne and caviar. The only thing waiting for me is what we affectionately refer to as "the burb," the ole family truckster. For some reason, on this day, unlike many others, I just don't have the mental strength to pull myself up by my bootstraps and act like everything is okay. The curtain has closed on the "it's okay" play and the habitual routine to my life is offensive.

The engine roars, and the air outside is filled with the smoke from the exhaust. I allow a scalding sip of coffee to slip painfully down my throat as I put the throttle in reverse and strain my neck backward, lugging out of the driveway. The roads are snowed over, only allowing single rows of tire tracks to reveal the concrete beneath. We've been snowed in for a week now. No school. No activities.

No highway. No hair appointment. Some might argue it is just a hair appointment. I mean, what's the big deal, right? Talk to your average housewife about that. It's a luxury. It's uninterrupted time. Time is the luxury, not the cut and color. The first several days of this batch of snow were exhilarating. Snowmen, snowballs, and snow ice cream were made and enjoyed. Two little snow angel formations still rest silently in our front yard. The two angels who made those impressions slumber quietly in their beds. They are warm, cozy, and bundled beneath footie jammies and quilted beds.

The roads begin to glisten with the first rays of sunlight. I drive on through my small, sleepy hollow Oklahoma town, and come to the red light. I stop. It is hard for my spirit to absorb that my strong and brave cowboy, anointed as God's man, will be five years old next month, and my mini princess, showered as God's worshipper, will be three years old. They are growing so fast, and no matter how I take in every moment as it comes purely before my eyes, they are fleeting way too fast for my affections of them being small to etch themselves within my being.

They are becoming the "arrows in the hands of a warrior" (Psalm 127:4).[3] They are my arrows, and I am blessed and strengthened by my children. I feel our newest arrow kick me sharply in the side. She is another mini-princess. Due in the spring, she has already been anointed to speak God's fulfilled promises of prophesy. I know the Sunday school answer that "they are my greatest ministry," and they are. I love, effort, and pray the pouring of the blood of the Lamb over them every day like liquid love. Motherhood is the

3

highest honor in my life. I believe that with all my heart. I believe it so much I have stayed at home to raise my babies. But I'm tired. I'm human and surprised that I am not the automatic robot I have my family and friends convinced that I am. My mind types out my emotions like the heavy weight of typewriter keys splattering ink against white paper, trying to convince myself of the adventure I'm desperate to find within the wilds I live. A car honks behind me, and I realize I've stayed at this light too long.

I am thankful the love of my life, snuggled under the down comforter in our room, was there to watch over our little arrows as they rest. Our year is dictated by the ebb and flow of a coaching lifestyle. My husband, a coach man by trade and passion, coaches Division II football. He coaches individuals, and it just so happens to include a game. Coaching to influence boys to become men isn't for the faint at heart. It isn't easy, and we all make sacrifices. It isn't just about the x's and o's. It doesn't start and stop on Saturday. Coaching happens Sunday to Friday. Coaching happens after hours. A year ago, my coach man was sitting in his office when a position player stopped by to talk. In a matter of thirty Holy Spirit–led minutes, out walked a redeemed and set free life, fresh off of laying his broken life at the foot of Christ. Weeks later, that player was baptized and raised to walk in new life. That is what it is all about. But in order to have that opportunity, the scoreboard has to be in your favor. You still have to win to keep the job, and we have just put to bed our second losing season. To stand with head held high in the face of so many invariables

is tough. It takes hour after hour commitment to not just the individuals but to the x's and o's. It takes a deep, long, sacrificing breath every time he has to answer his phone to take that recruiting call, answer that parent's question, or plan that trip to see the "next big thing." Those x's and o's don't always love you back. There is a saying among the sorority of coaches' wives, "We interrupt this marriage to give you the football season." It's sad but true. As wives we sacrifice, we give up family time, husband time, and down time. We open the doors to our homes, and the porch light is always on. We coach as a family, and we love it heart and soul. We opt to help raise the next generation while we try and raise our own families. The microwave can't heat up quality time; it can only reheat the spaghetti and meatballs, which can only fill your belly. It can't fill your heart.

The sleet thickens as I drive. My wheels slide as I make my left hand turn into the parking lot and the adventure for the day: Walmart. I turn into the spin and straighten out. The weight of what seems to be an attitude I can't shake presses down heavily on my shoulders. I know the uniform right answers; I was raised on them. Pray, trust God, and don't have a bad attitude. Yada, yada, yada. I also know that "there is always someone that has it worse off than you." But the problem with that is I am just human, and the weakness of my spirit at this moment is suffocating. Those right answers are just not giving me sufficient air to breathe fully or to live fully. How do I find the "It is well with my soul" my grandfather sang so grandly from the Methodist pulpit and then find the courage to agree with it mind, body,

and soul? Where is the adventure in the life I am living? I am quiet and still, and the radio waves of worship music seep through the vents like vapors that enter my soul. The sun has come up over the frozen clouds.

God is starting something in and through me. I am finding my life at an incredible crossroads. I am hoping there will be other sisters who join me as I step. He has used this snowed-in, no hair appointment day to devastate everything that needs changing. No hair appointment is just the straw that broke this emotional camel's back. He is drawing me in, and even though my heart is in chaos, I have the smallest sense there is a greater peace standing valiantly before me. The Lord, in His gentleness, is asking me just to breathe out and surrender with hands and a life opened up wide for Him. I can feel the need for a heart change.

He is starting a work at a time when quite honestly, from my limited human understanding, I'm at my lowest. I've never felt more sensitive, more vulnerable, and more chaotic in my life. Recent job changes, along with the stress of multiple moves, have tested me, pushed me really. Relational shifts alongside the challenge of raising a family and consistently managing and relentlessly organizing a household have pulled and stretched me. Digging through loads of an emotionally charged past, attempting to launch new dreams, and trying to build a life of influence has tear soaked my cheeks and wearied my resolve.

I have a happy life, a cherished life in fact. I've been a born-again, Spirit-filled believer for twenty-three years. I have a life filled with people I love, and I am surrounded by

the goodness of God's creation every day. I have my health, two children—and one on the way—who are the jewels of my eye. I am blessed with a husband who loves me, friends I adore with my whole heart, and a church that sharpens me. I should be "living happily ever after," right? And yet, as I sat in that ice rink of a parking lot drinking in a few more quiet moments, I admit my soul longs for more. More than a meal schedule for the week, the baseball and gymnastics taxicab rides, more than the safety of having all the bills paid at the first of the month, more than just living to say "doing fine" when asked how life was. I want a beauty that rests on the continual fount of the unfading glory of the King instead of the limited resources of a makeup counter at the mall or a yoga class at the Y. It's not depression, and self-pity doesn't produce anything. I don't necessarily want *different;* I just want *more* out of my *now*. More life. More inheritance. More purpose out of what I already had. I ponder and sit and dwell on the collective "all" in my life, and I ask God for the abundance of John 10:10: "I have come that they might have life and have life more abundantly."[4] I release my white-knuckle grip on the steering wheel, drop my hands to my lap, and rest my head on the helm instead. I weep for God to make me royal within the authority of my position as a daughter of the King. I want Him to replace the feeling I am just a cog within the works of the well-oiled life machine that was passing by without my heart and soul.

Ever been there? Found yourself at a crossroads in life, where God is ready to do a concentrated work in and through your existence, but you feel like all you are is a train wreck

just waiting to happen. Found yourself ready to launch in to the deep waters of God and make a heart change, but as you approach the waters, you pause. At first, you are captivated by the thought of God lavishly loving you, and you take a stride toward that road. But then something creeps, like a slow-moving ooze, into your conscience and reminds you you're too messed up. It tempts you to agree with the lie that you've walked too far in the other direction for God to want to spend time with you. Who are you fooling to think that road was meant for you? You aren't special. You claim defeat before you even experience a single movement.

Maybe it's your own voice; maybe it's the voice of a friend, a family member, a coworker. Maybe it's coming from someone you thought you could trust who has proven untrustworthy and defeating. Maybe it's the voice of your circumstances, your past, your present, or the paralyzing fear of an unknown future. What about the deafening voice of defeat coming from within your own frame as you walk? Maybe it's the resounding no of a snowed-in, no hair appointment kind of day? Regardless of what shape or form that voice takes, it's the voice of the Deceiver. The liar of all liars will use any means possible to try to convince you to shrink from abundant life. The truth is that you are not from a family that shrinks back. "Let us hold fast the confession of our hope without wavering, for he who promised is faithful. We are not of those who shrink back and are destroyed, but of those who have faith and preserve their souls" (Hebrews 10:23; 39). But if you're not careful, you can entertain those thoughts and that voice of deception

for too long, and before you know it, you've given him a great deal more undeserved space and comfort in the home of your heart than he deserves.

If you listen to the voice of deception long enough, you'll stop walking. You'll turn away from the road leading to life that you have been slowly, maybe even gingerly, ambling toward. You'll convince yourself you have to clean up your life before you can make a bold step to pursue Christ or more out of your life. You'll negotiate yourself away from the path of life and rationalize that there are plenty of smarter daughters out there to walk that road. Besides, aren't there already enough voices for Christ in this world? How could he ever use a weak and weary vessel like you to carry hope to the lost, the hurting, and the lonely? Doesn't He realize that actually describes *you*? Your shoulders slump, your steps slow way down as you turn back to living life as you always have. You'll continue to drip the oil into the gears of your life machine just fine. You'll be fine. You're sad, but you think yourself foolish for wanting more out of life, more out of the Creator of the Universe. You agree with the voice of deception, and you walk away.

God thinks it's about time to reevaluate who you really are. It's time to heal that broken heart and mend that torn spirit. It's time to open the eyes of your heart to see what the Father, the King, really sees. What He sees is the royalty of a princess becoming all glorious within.

The King's daughter is all glorious within! (Psalm 45:13)[5]

What He sees is a beauty worth lavishing with the life of His Son. He sees a creative genius just waiting to be

expressed. He sees beautifully worn-out hands and feet that are anxiously awaiting an opportunity to carry a cup of life-offering refreshment to the brokenhearted. He sees a daughter who, even though she has experienced the deepest of loss, has a whole world to gain. He sees tenderness for people placed in a heart that at its weakest, most submissive, most vulnerable place is actually quite radiant. He sees you as more than just a mess that can't quite pull it together. He sees His daughter becoming all glorious within.

Are you there? The intrinsic work of becoming all glorious within isn't for the daughter who thinks she's got it all figured out. It's for the daughter who's weak, wounded, lost, and feels like her caterpillar heart has been left to die in the middle of nowhere, alone and afraid. Becoming a Glorious Daughter is for the descendant of God who is humble enough to fall on her knees before the King and say, "I can't go on another day without *all* of you, King Jesus." She might not feel like she's even worth the time of day, but she is willing to place her life in the palm of the King's hand to be restored. She is willing to submit all of her life to the re-creation process. She is willing to be transformed from the inside out. She might put on the "face" and function in the world just fine, but in the depths of her heart, she is crying out for healing. That is *exactly* who Jesus came to save, love, and pour out His life to remind her she is His most beautiful creation and worth everything to Him.

As my car idles in the Walmart parking lot in the snowy early morning hours of a cold January Saturday, I sit in the driver's seat, spiritually bankrupt and crying. I have broken

beneath the weight of feeling weakened by years of insecurity and the pain of unworthiness. I am crumbling beneath the sandy foundation of the unrealistic expectations I put on myself and my surroundings. Expectations I realize no single, earthly individual could ever live up to. My attempts to *do* more in order to *gain* more out of life are falling short. "Given out," wallowing in my feelings of insignificance within the role of charitable "do gooder," God draws me to His side. He gently shuts my mouth and presses hard on the stop button of the vicious tape recorder in my mind. It was there that He starts over from the beginning, re-teaching me who I really am.

The King, in His everlasting magnificent regal royalty, can take up residence in every sphere of our heart. Not just in part, but in whole. I have discovered, though, the fulfillment of that dream hinges on us living for the King from the inside out. It comes when we consent and allow Jesus to situate Himself so far down in our bone marrow that His presence and grace work past the highs and lows of relationships, the unsettling nature of change, the deafening echo of deep loss, the vicious cycle of one ordinary day after another, the ins and outs of marriage, and the ups and downs of raising children. I have seen and can testify that when we surrender to God's ways, freely opening our hearts as an offering to Him, we step into our authority and position as the royal heir to the Throne of Grace, dreams are fulfilled, and a better life is ignited.

The cold winter winds swirl through my hair as I approach the automatic doors of the Walmart. I raise my

prayers as twirling whispers up to Heaven, and I plead for the Father to take me up in a whimsical romance. I plead for a deeper relationship than I have ever known. And as I whisk through the doors, the Holy Spirit whispers with a soft, warm voice. "Yes, my daughter, I will take you on an adventure. It will be like no other adventure or fairy tale you have seen or experienced. It will be a real-life, gritty, sleeves rolled up, persuaded, convinced, situated, decidedly courageous, and gloriously beautiful tale of adventure and overcoming and victory. And you, my precious one, my dear daughter, will be caught up as a beauty of God."

As I weigh the difference between the crusty French baguette and the ciabatta, I am *more*. Decidedly different, saved, and radiant; I am more royal than when I walked in. A seed was planted. A voice was heard. Suddenly there was growth within my soul that desired to become something more, something deeper. A bright butterfly of awakening to the Father's love and pursuit for His daughter is breaking through the hard-cracked cocoon of a Bible beating, churchgoing, caterpillar that had spent a lifetime learning *about* God. The wisdom of my parking lot revelation is becoming clear. God wants me to receive my position and the grand adventure of being His daughter. He wants to showcase love to His child, I just need to be positioned to receive it. I'll finish gathering groceries for my slumbering troops. I'll drive home and love, serve, and give with more because I have swallowed deep and long the Spirit of the Lord, and his moving has stirred a change in my heart. On this ordinary calendar day, while the snow drifts high on

the roadsides, my Lord has received my surrender and is reaching low to raise me and lift my head to new horizons. I may not have left my physical location in any way, but my caterpillar heart has submitted to the creation process of becoming all glorious within, and I am assured to emerge as a beautiful butterfly.

> Dear Beloved Father, please heal every wrong concept of the King that we have. Every destructive thought or whisper that we have believed about ourselves, we ask grace and mercy to wash over our desperately sick interpretation of Christ and the events of our lives. In the Name of Jesus, show us why we are here and how you really see us, as beautiful daughters becoming all glorious within. Regardless of what we've done or believed, we pray that you will open the windows of Heaven to bring right perspective to our hearts and wisdom to the revelation of authentic beauty. In Jesus' Mighty Name we pray, Amen.

2
PEARLS

Once upon a time, there was a pretty princess with golden curls that shined like sunrays, crystal blue eyes as deep as the sea, and a sparkling cherry pink dress. Around her neck, she wore a glimmering, colorful string of plastic pearls. She would put them on and twirl around the castle, cascading the colors of her pearls across the walls. She felt moments of prominence with them around her neck. At times, she caught glimpses of beauty in dim reflections around the castle walls. After the princess had worn the pearls for a long time, the dazzle started to fade. The plastic pearls became cloudy and even started to lose their shape. The princess was sad that the colors of her pearls did not radiate like they used to. As the pearls lost their luster, she felt less and less pretty. Then one day, the princess decided to stop twirling all together.

The princess had a very compassionate father, the King. One day the King noticed his daughter walking through the garden, looking awfully gloomy. He walked down the steps of the castle, knelt down by the bench she had sat down on,

scooped her up in His big arms, and held her tightly. The princess explained how her pearls did not twinkle or glisten anymore. She expressed her broken heart and said she didn't feel very pretty now that her pearls did not dazzle and shine. The King took her face in His hands and smiled. He asked her to give up her plastic pearls, close her eyes, and hold out her hands. The princess paused and was a little surprised at His request. She was hesitant to let go completely. Even though she wanted shiny new pearls, she was almost more afraid of having nothing at all. Why would He want her ugly, dull, colorless, and lifeless pearls anyway?

The King reassured His princess, His daughter, with His smile and His strong and tender arms embracing her warmly. Again He asked her to slip off her pearls from around her neck and place them in His hands. With big tears welling up in her eyes, she gently took off her pearls and gave them to her father, the King.

With a quivering lip, the princess closed her eyes and held out her hands, feeling the set of plastic pearls slip through her fingers and into the palm of her Father. The King took her old, ugly, dull, colorless, lifeless pearls and wounded heart, and replaced them. When the princess opened her eyes, she couldn't believe what she was holding. In an instant, her Father had replaced those unattractive plastic pearls with a brand-new set of real, glittering, dazzling, and radiantly glorious pearls. The newly adorned princess confidently wore the authentic string of pearls around her neck. At once, the King took her hands, and together they whirled and twirled all over the castle. The radiantly glorious set of

pearls never faded. The dazzle of those pearls around her neck only became more spectacular as the pretty princess grew and lived happily ever after in the Kingdom![6]

Nice story. Wouldn't it be great if it were that easy? I don't know about you, but I did not wake up this morning wearing a pretty cherry pink dress with my hair neatly placed in golden ringlets, sparkles on my cheeks, and a bag of fairy dust in my hand to twirl away magically all of my problems. No, this morning I blazed out of bed late in a gray hoodie, gray sweats, fuzzy slippers, and a head of hair that vaguely resembled a disheveled bird's nest. My "castle" looks more like a three-bedroom rental house with toilets to clean and laundry to fold. There was breakfast to make, folders to sign, lunches to pack, diapers to change, coach man to kiss, kids to race to school, and black coffee swirled with hazelnut creamer to choke down. Real life for real folks is gritty and demanding. Fairy dust not included. "Fairy-tale faith" is a myth and a tragedy for those still thinking it exists. I don't want to be a killjoy or antagonist, but I want to be honest. It is a journey and a battle to follow Christ. To stay with Christ. A great deal happens in life, and just sprinkling fairy dust over it won't change a thing. Poverty exists. Families are split by addiction. The good die young. Stress chokes joy. Debt steals dreams, and fairy dust won't help us fly away to never-never land.

However, there is a King who wants to see His daughters band together and start living lives full of His radiant beauty … and that yes, we ride off into the sunset to live happily ever after in the Kingdom. Don't count out the

fairy-tale idea so fast though; just read the description. No, life isn't a *fairy tale,* but it can be a *Truth* tale. To make a proactive stride toward becoming all glorious within, we have to approach the Lord with childlike wonderment and fairy-tale eagerness. Even though death, sickness, and loss swirl around us every day and dash our hopes for fairy-tale living, I still want the romance of happily ever after. I want to be the Proverbs 31 woman who laughed at the days ahead: "Strength and dignity are her clothing, and she laughs at the time to come" (Proverbs 31:25).[7] I have a favorite lime coffee mug with "LOL" etched in big white letters, and every time I pull it out of my cabinet, I think of the P31 woman who lived a real life and still made a choice to laugh out loud. To me, that is the equivalent of twirling. In a real life, I want to twirl, laugh, and live like a princess caught up in a beautiful tale. Like I said in the previous chapter, I want a real-life, gritty, sleeves rolled up, persuaded, convinced, situated, decidedly courageous, and gloriously beautiful tale of adventure and overcoming and victory. I want a real fairy-tale I can sink my teeth into.

But completely discounting the credibility of the tale of the pretty princess is wrong. It isn't all bad to think magically and romantically about life and the hope of fairy-tale living. It goes wrong when we put our faith and trust in the wrong source: plastic pearls. Like the pretty princess, trusting the proper Source for the fulfillment of our dreams will expose the real pearls to life. She placed her dashed hopes in able hands and awaited a miracle with childlike faith. Approaching Christ in the way my daughter does

when she gets all dressed up and wants her daddy to dance with her is pure and precious. And Jesus loves the heart of a child. As a matter of fact, when the disciples tried to push away the little children, Jesus rebukes them: "Then children were brought to him that he might lay his hands on them and pray. The disciples rebuked the people, but Jesus said, 'Let the little children come to me and do not hinder them, for to such belongs the kingdom of heaven" (Matthew 9:13-14).[8] Childlike faith embodies the kind of humility required to truly see Christ and receive the blessing of abundance in His hands.

I don't want us to be ashamed of being hopeful romantics about life. I am just suggesting we start looking for the Truth tale in all its glory, submitting to the right King and standing strong in our rightful royal position. Visualize yourself as the princess in the story, and maybe like her, you have found a few plastic pearls you were sure would bring you happiness. What you have discovered is that they have become cloudy, and the once vivacious colors they cast have dulled. You are sitting in the garden dissatisfied, disappointed, and feeling anything but royal.

In desperation for acceptance and the unrelenting pressure to please others, did you put your trust in a group of friends only to find that gossip and the disapproval of the group stopped you mid-twirl? Is your necklace a string of addictions that promised to fulfill but only left you alone and wanting more? Maybe your string of pearls was the safety of a faith you could understand—a life you could manage and manipulate, alongside an attainable set of rules

that governed your existence. What you found out is that a string of safe living only leaves you hemmed in by rules and obsessed with don'ts instead of alive with do's.

Have you twirled all over the castle of life with a perishable string of pearls? Becoming all glorious within will start when you are willing to slip off the string of plastic pearls, which includes any portion of your life that feels tarnished, dulled, colorless, lifeless, or dazzle-less. When you are willing to place that necklace into the hands of the King, you begin becoming all glorious within.

Nearly seven years ago, I had an online business called String of Pearls. It was a couture design company that catered to the needs of the mini-princess. We designed and manufactured formalwear for girls between the ages of two and twelve. One time I remember designing a dress for a beautiful little girl. She was quiet and rather shy. When we started the design process, I could tell she really wasn't interested in wearing a puffy princess dress. She would have much rather stayed in her comfy T-shirt and shorts. On the final fitting, though, there was a transformation. She took the gown to the bathroom to put it on so I could double-check the fit. When she emerged, she was just radiant, holding her head high. She was transformed. Then she started twirling. Right there in the fitting room, she twirled and twirled. It was precious, tender, magnificent, and captivating all at the same time. Her mom and I watched her take on the confidence of a princess just by putting on a formal gown.

Being clothed in the right garment, with the right accessories, and abandoning our inhibitions will result in

twirling transformation. I know it sounds so simple, but it really is. Remember, childlike abandonment and trust produce the humility and freedom required to receive the fullness of a gloriously beautiful life.

By delighting yourself in the love of the King, He will start to bring you in to a revelation, an understanding, of what His desires are for your real life and circumstances. Your Truth tale will start to become a reality, and the fulfillment of your heart's desires will become scripted into the story of your life when you lay it all down.

"Delight yourself in the Lord and He will give you the desires of your heart!" (Psalm 37:4).[9] It will begin to take form in your life as you are willing to be transformed by a new designer gown of righteousness. By cultivating and laying down the areas that prevent us from full fellowship with the King—like sin, strongholds, addictions, guilt, and shame—we are clothed with a new nature, a new beauty, and a glorious new pearl necklace.

> For He has clothed me with the garments of salvation;
> he has covered me with the robe of righteousness ...
> as a bride adorns herself with her jewels. (Isaiah 61:10)[10]

"When I get all growed up, I'm gonna wear that dress and get married, and Daddy is gonna walk me down the aisle." That was what I heard this afternoon, when I sat down at my kitchen table to work on some writing. Ainsley's words from earlier that day were ringing in my mind and echoing from my heart. You see, I recently framed some of

our wedding pictures and hung them up in our bedroom. Ainsley has been fascinated. She has asked me a million questions about when Mommy and Daddy got married.

"Did Daddy buy you that pretty shiny ring when you got married, Mommy?" "Did you marry Daddy in that picture Mommy?" "I like your hair in that picture, Mommy. It's cutie! What's that sparkly thing on your head, Mommy?" "I loooove your dress, Mommy! What kind of princess dress is that?"

Last night, when I was tucking her in bed, she persisted in inquiring about my wedding dress, and I finally asked her if she wanted to see it. To my heart's delight, her eyeballs nearly popped out of her head, and she ecstatically replied, "Yes!" So I promised her I would pull it out of the closet the next day, and she could view it through its little "wedding dress viewing window." This morning, first thing: "Mommy, are you going to show me your dress?"

Away to the closet we dashed. The big unveil did not disappoint, and my heart was full when she responded immediately, "When I get all growed up, I'm gonna wear this dress, Mommy!" Of course, every Mommy's heart's wish is that their daughter will want to wear their wedding dress on their own special day. That's why we shrink-wrap it in a three hundred dollar box with a viewing window for twenty-five years. We always think that *our* dress will be the timeless design that will never go out of fashion or style. Then in some small way, we will have passed on a beautiful treasure of what was a most profound day in our past. In actuality, she will probably want her daddy to

buy her a brand-new sparkling gown when it's her turn. My *timeless* gown will probably have acquired years of dust only to be turned away and adored by me alone, while my daughters simply view it through its neatly placed window. The deeper and more profound thought this experience with my daughter has provoked though is found in this statement: Our hope and prayer is that, that day in the past will have a place in our daughter's future.

But as I dwell on the above statement, I'm hit with a more profound *day*. Every day I make a choice to follow Christ. Every day I make a choice of who and what I am living for. Every day could very well be *the day* that has a profound place in my daughters' future.

With every new treasure, or pearl, of God's Word I uncover and then actively apply, I am advancing in my faith. With every new spiritual stake I drive down into the earth, I am claiming *that day* as *the day* I desire to have a profound impact on my children's future. I'm suggesting that we begin to clothe ourselves with the "garment of Christ" every day, so we are "boxing up" a much grander garment than a mere earthly wedding gown.

> Awake, awake, put on your strength, O Zion; put on your beautiful garments, O Jerusalem, the holy city; for there shall no more come into you the uncircumcised and the unclean. Shake yourself from the dust and arise; be seated, O Jerusalem; loose the bonds from your neck, O captive daughter of Zion. (Isaiah 52:1-2)[11]

God is calling his royal daughters into a new era of blessing for themselves and the whole world. By "putting on your strength," God is calling you to live as He has intended you to live: fully beautiful, fully adorned, and fully radiant ... just as a bride on her most special wedding day.

My wedding day was one of the most brilliantly gorgeous days of my entire life. That one decision will continue to impact my children as my husband and I build a life together in front of them. But more important than the "moment" of that day and what I wore is the "strength of Christ's might" that I wear every day. Those days and what I wear on those days count just as much. The "everyday" dress matters just as much as the wedding dress.

As we become willing to take off our fake pearls, we can anticipate beauty and authentic pearls of "love, joy, peace, patience, kindness, goodness, gentleness, faithfulness, and self control" (Galatians 5:22-23).[12] We can anticipate a double strand of pearls for all we have given up and laid down at the altar of the King. "Instead of your shame there shall be a double portion; instead of dishonor they shall rejoice in their lot; therefore in their land they shall posses a double portion; they shall receive everlasting joy!" (Isaiah 61:7).[13]

So when Ainsley "gets all growed up" and wears my wedding dress, I hope she is adorned with much more than an earthly garment. I hope she is adorned with the pearls of wisdom, grace, loving-kindness, and compassion. As the Hebrew word *nipleti* states, she believes to the depths of her core that she is "fearfully set apart." My prayer is that when

her generation of Glorious Daughters adorns themselves for the beauty of their wedding day, they are clothed with every beauty and strength of the Bride of Christ.

Fake pearls won't last. Unbelief won't shine into satisfaction. Acceptance won't shine into contentment. Self-reliance won't shine into production. Physical mutilation won't shine into release and control. Stress won't shine into results. Worry won't shine into progress. Denial won't shine into change.

Take off those pearls that don't last, and prepare yourself for a new necklace. A new garment. A new name. I love how God proclaims this truth in Isaiah 62:3-4a: "You shall be a crown of beauty in the hand of the Lord, and a royal diadem in the hand of your God. You shall no more be termed Forsaken, and your land shall no more be termed Desolate, but you shall be called My Delight Is In her ... for the Lord delights in you!"[14]

Open your hands as you surrender, and trust the King to place a set of real dazzling pearls around your neck that inspire and empower you to twirl though all your days. They will become Pearls that inspire unexplainable joy as you choose to give thanks during a financially pressing season. Pearls of grace and love as you nurse your hungry infant in the wee hours of the darkest night. Pearls of patience while you wait for that torn relationship to mend. Pearls of beauty that work from the inside out while you serve your friends and neighbors. Pearls that last.

Pop open the plastic fastener of your fake pearls, pretty princess. Let them collapse through your fingers as you feel

them fall into the hands of the King. Let go of your held-in breath as you wait with nothing in your hands. Then allow your being to ignite as the softness of genuine Pearls adorns your neck. Throw your head back, close your eyes, and twirl.

3
#HASHTAG

"What's her name?"

"Shelby Kate." The exchange took maybe three seconds. In three seconds, a life had a name.

I was watching TV when I went in to labor with my third little arrow. She was one day early from her actual due date. I labored at home for several hours while scrubbing my house to lemony-fresh oblivion, all the while squeezing my coach man's hand so hard it began to resemble a wrinkled raisin. I was happy to have the excitement of going into labor at home, painful as it was. I was ready for that adrenaline rush. After a few hours of that rush, I was ready to situate myself and my laboring body in a hospital bed, with an anesthesiologist close at hand. I labored in the hospital for a few hours, and out she came. Shelby Kate. There she was. Nine months of waiting, growing, praying, hoping, planning, and preparing for new life. In an instant, a mini-princess had arrived, and now she had a name.

Her birth certificate had been filled out, a Social Security card would soon arrive in the mail, and she would be entered into the world system. She had been proclaimed as Shelby Kate, a deeply Southern name with strong ties to a favorite movie of mine. Her technical etymology reads "sheltered, pure, and clear." Anyone who knows or has heard my now seven-month-old knows that "sheltered" gives way to being the life of the party, and "clear" is an understatement. The woman has a clear voice and will make it known ... loudly if need be. Beyond the technical meaning of her name, the Lord had long before proclaimed to me and to my coach man that her name, and in a greater sense her life, would proclaim the prophetic promises of God. Our prayer is that her life exceeds the boundaries of her given name. Our prayer is that her life exceeds labels, roles, and assignments. However, it all starts with a name. There is so much to a name. It is so very personal. When the love of your life whispers your name, every sense in your body tingles. If your parents shout your first and middle name down the hallway, you better be coming up with some fast answers. Your name being announced over a PA system in a crucial minute of a playoff game can make superhero adrenaline race through your body. There is power in a name.

As the steam engine of life rolls along, and our names start to get hidden within the brambles of the days we live, wife, mom, college student, mentor, sibling, caretaker, cook, or maid start to rise up and take a seat above our name.

Some battle the labels of being terminal, gifted, divorced, addict, single, or burden. Some are labeled infertile, insecure, or damaged. Labels can stick like sticky notes to our foreheads. Shy, rejected, abused, victim, failure, unpolished, unsuccessful, bankrupt, broke. Those are only a fraction of labels or names we can knowingly or unknowingly place on ourselves or others. Labels can roll off the tongues of friends, family, and associates like hot lava burning holes in every part of your heart. A label can define and dismiss you in an instant. Some labels can be given so much authority in life that whether they are true or not, we can start to live according to those labels and not to God's Truth.

I've had a hard time wearing my name tag to church. Our church recently had formal, real-deal, magnet-backed name tags made for every member. It was done in an effort to increase comfort as our church family grows, and we need to know more names. It's just nice not to have to say, "Hey ... you," so much. I haven't worn mine but once. Name tags make me feel funny. I'm so proud of my given name. No problem with Cari Lyn Trotter ... nothing at all wrong with that name. The problem is that the life behind it seems to mess it up on the regular. I have all sorts of labels and roles posted on my forehead. If you could see me from the inside out, I might look more like a sticky note mummy rather than a 5'3" blond with blue eyes. I'm afraid of the name tag, because the lies of the Enemy tell me others will read more than my name; they will read every sharp thorn I have ever grown, even those I have trimmed back and cleared up after moving forward healed and whole. I nervously anticipate they

will rise above who I am becoming. As I put my name tag on, there is always this looming fear that a new introduction will read a label, make a fast judgment, define and dismiss me, read my label, and not my name.

With the whole world dropping Twitter bombs from the sky, hash tagging seems to be the newest pastime. They usually involve the emotion from the most recent circumstance or experience. It is a quick #getoutofgrammarjailfree card run-on sentence of how the tagger feels about the moment. It's a way to label moments and, at times, people. When I think about labels, it is such a great way to understand how, as women, we have actually been doing hash tagging in our heads for years. Now we just have an outlet for it. For me, when I think about wearing the "name tag" that reads more like the longest hash tag ever, it's a little disturbing how many labels I can put on myself.

#momthatgetsmaxedoutmorethanshelikestoadmit

#wifethatisntalwaysavailableforherhusband

#emotionalrollercoaster

#sadaboutbrokenrelationshipsIdlovemendedbutinsist
onstayingbroken

#acceptanceaddictworkingontrustissues

#compulsiveworrier

#doubtingThomas

#insistentprocrastinator

#highlyinsecureatanygivenmoment

The press of negative labels can threaten to belittle the power of your name and your position as a daughter of God. Life labels can threaten to "kill, steal and destroy" (John 10:10)[15] the beauty of Christ. Fixating so much on what I can't be, what I'm not, or what my life is not instead of believing and agreeing with all that God says I am in Him is dangerous terrain. If I give those labels too many inches, they will take more than a mile of heart territory. In an effort to become all glorious within, we have to first pronounce our name and give it the proper authority and place in our lives. We are daughters of God. Everything should flow from that place, from that name, from that position.

Mary could have completely freaked out, and with just cause, when the angel Gabriel came to tell her she would be the mother of Jesus ... before she was married. Negative labels were immediate and spread like wildfire through her small Nazareth town. The beauty salon on Main Street Nazareth would have seventy gossip answers for all of this and would be ready to define and dismiss poor Mary with all her labels in tow. She had to make a fast choice to trust God—to trust her position. She had to believe God was telling the Truth about who she was and whose she was. "And blessed is she who believed that there would be a fulfillment of what was spoken to her from the Lord" (Luke 1:45).[16]

As Shelby Kate gets older, she will have to believe me when I say what her name is. More than likely, she isn't going to call me a liar when I tell her her name. She will trust me and accept it. I'm the one who gave it to her. She isn't

going to disagree with the fact she is my daughter. Now as her earthly parent, she and I might go round and round at times, but no matter what, her position is secure. Her place in her family is permanent. And our prayer is that through the confidence of that position, she has freedom and safety and feels loved in and by her family.

The King's daughter. That describes you and me. That is the name our Father has given us. That name is secure. If we have come in to a relationship with the Father, we are children of God and, therefore, a daughter of the Most High King. "He predestined us for adoption as sons (and daughters) through Jesus Christ to Himself according to the kind intention of His will, to the praise of the glory of His grace, which he freely bestowed on us in the beloved" (Ephesians 1:5).[17] Child of God, daughter of the King. That is our name and our only label. And God wants us to feel free, safe, and loved while living out of the authority of our name as a child of God. Yes, I do have a given name. I don't just go around signing a Hello My Name Is card with "The King's daughter." However, before I put my black sharpie down on that name tag, I should hear God say "My daughter" to me as my hand scribbles out the name Cari.

If I am going to pursue more to my "now" life, I have to start operating out of who and what God says I am, and that would be a daughter who is becoming all glorious within. Every other role or label should flow from that one position ... from the single royal authority that is Christ. I will be more likely to approach my day with so much more

of the fruits of the Spirit if I start off with that one name singing over me. I am a daughter of the King and then I am a wife. I am a daughter of the King and then I am a mother. I am a daughter of the King and then I am a student, a teacher, and a minister. I am as guilty as the next woman going in and out of Bible Study as a worrier, a doubter, or with a long list of needs. Now there isn't anything wrong with coming to God needing to word vomit or spill your broken heart. He is there for us, and He is not looking for perfection—just persistence. But I forget to come just as a daughter first and foremost. The purity of that humble, submitted, trusting position helps me hear and receive from the Father so much better. When I approach my day with "I am a daughter of the King" first in my mind, it frees me to be controlled by the Spirit. When negative labels threaten to overtake me, I can go back to who I am and whose I am and override any effort of the Enemy to say otherwise.

When you take the risk of laying down your pearls and putting on a new strand of Authentic Pearls, you get a new name. All those false labels or limited roles you play don't have the control over your heart that they used to. "Tell daughter Zion, 'Look! Your Savior comes, Ready to do what he said he'd do, prepared to complete what he promised.' Zion will be called new names: Holy People, God-Redeemed, Sought-Out, City-Not-Forsaken" (Isaiah 62:9-11).[18]

Whether you are aware of it or not, a war is raging. The battle is on to steal the Bride, the princess, and carry her off to the dominion of darkness. To steal her away to the

lost sea of bitterness, resentment, unbelief, and anything but a gloriously beautiful life. Life will happen. The dishes won't get done, the laundry will pile up, the list of toddler demands will overwhelm you and lock up the gears of your heart: #mommyguilt.

Life will be too short. Friends will bury their children, and your heart will ache for the finality of earthly loss: #myfriendsdaughterdiedtooyoung.

Cancer knows no age limit and spreads mercilessly across our generational landscape. Its label can sting: #nofastcure.

Debt can threaten to swallow you alive and anchor you down until you die. Debt collectors become sharks in the water: #bankrupt.

Love can grow cold when life's demands steal your time. Life spreads thin. Hearts can ice over when not dealt with kindly. Romance can seem like a distant dream: #nomorecandlesandrosesforwornoutlovers.

For every false hash tag label the Enemy tosses your way, God has a new name to shout over you.

> #theprincessisallgloriouswithin
>
> #royalsarealwayspretty
>
> All glorious is the princess. (Psalm 45:13)[19]
>
> #youhaveabeautifulinheritance
>
> #mydaddysrich
>
> The lines have fallen for me in pleasant places; indeed, I have a beautiful inheritance. (Psalm 16:6)[20]

#youhavebeengivengraceupongrace

#oopsmybadnobigdealthanksdad

And from his fullness we have all received, grace upon grace. (John 1:16)[21]

#youareforgiven

#justhappytobeheredad

In him, we have redemption through his blood, the forgiveness of our trespasses, according to the riches of his grace. (Ephesians 1:7)[22]

#theKingisatrustworthydefender

#dontmakemecallmydad

The Lord is the strength of his people, he is the saving refuge of his anointed. (Psalm 28:8)[23]

God cares about your name. He cares that you understand the importance of your position as His daughter.

The genealogies of the Bible can be a chronological beat down to read through. At times, you can feel you need a PhD in Hebrew languages to have any hope of pronouncing them properly. You end up just opting for a first initial naming, especially if you are called on to read a set of genealogy scriptures aloud in Bible study. At other times, you could be tempted to skip over that name mess entirely. Take a deeper look at those names; there might be some in the lineage of Christ you might just recognize. What about Ruth?

Ruth had to overcome the negative connotation labeling her whole life. Hash tag it out: #looserfromNotownMoab. She was from a bad town that did so many things wrong the entire citizenry was labeled "bad news." "No Ammonite or Moabite shall enter the assembly of the Lord; none of their descendents, even to the tenth generation, shall ever enter the assembly of the Lord" (Deuteronomy 23:3).[24]

Her only hope was to marry out of the mess of her people. She did that. "And they took for themselves Moabite women as wives; the name of the one was Orpah and the name of the other Ruth. And they lived there about ten years, and both Mahlon and Chilion died" (Ruth 1:4-5).[25] Then he died. She was married ten years and then he died. She was alone and labeled again. She was a widow: #tooyoungtobeawidow.

In the wake of so much grief, one would completely understand going back to what seemed comfortable, even if it was messed up. Her mother-in-law, Naomi, gave her the blessing to leave and go back to Moab and their gods almost out of pity. She wanted Ruth to be comfortable and maybe find rest. But Ruth refused to go back. "But Ruth said, 'Do not urge me to leave you or turn back from following you; for where you go, I will go, and where you lodge, I will lodge. Your people shall be my people, and your God, my God'" (Ruth 1:16).[26] Ruth stayed to serve. Now she was a widow living with her mother-in-law: #helpingoutasadmotherinlaw, #ihavenolife.

Ruth longed to be loved again. She still believed and lived beyond every label circumstance threw her way. She served, loved, and gave. And she found her kinsman redeemer. She found Boaz. "Moreover, I have acquired Ruth the Moabites, the widow of Mahlon, to be my wife in order to raise up the name of the deceased on his inheritance, so that the name of the deceased may not be cut off from his brothers or from the court of his birth place; you are witnesses today" (Ruth 4:10).[27]: #overcomingeverylabeltoleavealegacy.

Ruth left a legacy. God cared about Ruth's name. He cared about it so much that He decided to rewrite Levitical law and list her name in His genealogy list of ancestors: "and to Salmon was born Boaz by Rahab; and to Boaz was born Obed by Ruth … Therefore all the generations from Abraham to David are fourteen generations; and from David to the deportation to Babylon fourteen generations; and from the deportation to Babylon to the time of Christ fourteen generations" (Matthew 1:17).[28]

There were generations after generations of people before Jesus' soft cries were heard in that Bethlehem stable, and yet Ruth's name got a mention. Ruth's name was remembered. Not Ruth the widow or Ruth the Moab. Not her label. What was remembered was her name, written out to signify her position in the family of God.

Life will happen, and labels will shoot out and splatter all over you like an out of control paint gun if you are not clothed in the protective nature of your position in Christ. When the war starts, you don't want to be a nameless

citizen caught in the crossfire of a life of unredeemed labels. You want to be the intentionally protected, rightly labeled, and perfectly positioned daughter of the Most High King.

WAR

A CaringBridge message comes through my phone right before I go in to kiss the cheeks of my sharp arrows as they sleep soundly after a dinner night out of eating with chopsticks and laughing, hugging, and making memories. Their bodies rise and fall with strong healthy breath. I reach for my phone and my eyes burn as I read the heartache of a friend.

> A shattered soul does not describe this, nor does broken heart. We are, as many of you have told us, at a loss for anything. I have tried numerous times to make this entry and stopped. It is the strength of your word, prayers, and kindness that I do this.
>
> Our precious angel Lauren is in the arms of Jesus.
>
> How we got here, we will never know. How we will go on this journey, we will never know. How our lives will be from this point forward, we will never know. We are broken.[29]

Kirsten's words spiral down my heart like a lead ball. My heart is wound tight. Those heavy words of death and loss pierce my soul as I reread them to my husband. Lauren, her daughter, was only three years old. How can she already be gone? Kirsten was a friend and sorority sister in college. She was older than me, and I always admired her. And now, walking through the pain of her loss, I am at a loss for words, still admiring her. I am rendered speechless. On February 20, 2008, Lauren was diagnosed in utero with a number of congenital heart defects: tricuspid atresia, dextro-cardio-version, atrial septal defect, ventricular septal defect, malposition of aorta, and hypoplastic right ventricle. Lauren successfully completed the first two surgeries: BT shunt on June 13, 2008, at ten days of age, and the Glenn shunt on October 13, 2008, at four months of age.

Lauren underwent her third and final operation, the Fontan, on July 20, 2011, at three years of age. She bravely battled many complications and was welcomed into the arms of our Lord and Savior Jesus Christ on July 22, 2011.

The news of Lauren's passing has me overflowing into the arms of my husband, sobbing. Sobbing for my friend. Sobbing for the brokenness of this forsaken globe. Sobbing for loss. Sobbing for pain. Sobbing for the sting of death that's felt on earth. My ears ring with the vicious echo of the Enemy's shouts of "War!" Its war, this life, and the battles are fought on the hallowed grounds of our hearts.

My radiant friend Kirsten is a daughter fighting a war. It's a war for her heart.

During this time in the history of the world, there are so many wars waging. You cannot turn on the television, click through your local radio stations, or pull up your e-mail without catching wind of a war that puts some region of the world in conflict and turmoil. There are wars being fought for oil, hunger, politics, drugs, poverty, marriages, diamonds, religion, human trafficking, children, lifestyles, and addictions. The list could go on and on and on. We live in an age and generation of war. However, living in my quiet small town USA, there is no physical war raging in the streets. There are no picket lines to mention out my front door. There are no mobs or gangs screaming slanderous language and roaring on the streets. There are no bomb threats, no arrests, and no public trials taking place. No tangible persecution where I live. I am free to listen to my Kari Jobe and Hillsong United worship, my big ol' English Standard Study Bible flopped open on a table, with no immediate threat to me finding and living in abundant freedom.

Yet a war is raging. A clear and present danger is pressing in on every heart. I am willing to bet that each unsuspecting café latte drinker in your local Starbucks or casual Target shopper is waging an intangible war. As you sit quietly reading your book, sashaying through the aisles of home décor, or typing on your laptops while listening to Pandora, someone is battling something. "For we are not wrestling with flesh and blood [contending only with physical opponents], but against the despotisms, against the powers, against [the master spirits who are] the world

rulers of this present darkness, against the spirit forces of wickedness in the heavenly (supernatural) sphere" (Ephesians 6:12).[30]

My Facebook feed scrolls through, spitting out lazy college-day pictures, Christmas pictures, updates on new books, YouTube videos of politicians losing their cool on national television, and the latest menu items; most posts are mind-numbing. And then I see a friend post for prayer. "Please pray for Lucy. She is having a very, very rough night." My friend Ryan is the mother of two beautiful girls who suffer from a rare and terminal genetic disorder. Not one, but two girls. Nonketotic hyperglycinemia, also known as glycine encephalopathy, has caused a host of problems for her daughters, including apnea, epileptic seizures, mental retardation, heart issues, vision issues, mobility issues, and GI issues. Her girls will likely mentally stay in a young infant age, regardless of how big they grow.

There is a daily fight for their lives, and most recently, they have had to fight with both of them in the hospital. I intercede and lift hands high, crying out, "Arise, cry aloud in the night, at the beginning of the night watches; pour out your heart like water before the presence of the Lord; lift up your hands to Him for the life of little ones who are faint because of hunger" (Lamentations 2:19).[31] I beg God's presence to be revealed, but my heart's cries feel hollow and insignificant. The Enemy's slithering ploys for chaos and dissention of health hiss with venom, "War!" My beautiful friend Ryan is a daughter fighting a war. It's a war for her body and soul.

I can hear the sounds of big band Christmas music playing and the clanging of my husband rinsing off the dishes from dinner as I rub the back of my firstborn arrow while tucking his sick little body in bed. The flu is no fun, especially when it hangs on for a week. With the holidays in full swing, being sick doesn't really fit in to "the plan." Like any mom, I fear it running through the whole house. I can feel the tightening of "sick" creeping up and around my neck. "War!" the Enemy shouts to my soul.

I am a daughter fighting a war. It's a war for my spirit.

The battle cries of others ring through the night watches.

A job is lost. "War!"

A marriage is torn by infidelity. "War!"

The long, unsatisfying drink of drugs doesn't numb the pain like it promises. "War!"

The confrontational nature of a volatile relationship frays you at all sides. "War!"

Singleness taunts you while you wait for Prince Charming. "War!"

The gossip about you finally hits your ears, and it stings. "War!"

The pleas of the psalmist spill forth from our despair. "Turn to me and be gracious to me, for I am lonely and afflicted. The troubles of my heart are enlarged; bring me out of my distresses" (Psalm 25:16).[32] In the midst of the shouts and assaults of war, the Enemy's intent is to get you to doubt your efforts, distrust the direction of your leadership, and second-guess your own ability. His ploys are in place to

42

tempt you to live with clinched emotional and spiritual fists. After the pain of battling, who would want to risk again?

God, the King, wants to articulate the feelings, emotions, and weaknesses that are associated with overcoming the circumstances of our lives that shout, "War!" Most often, those feelings of war won't fit into the neat and tidy Sunday school answer box. There is a sense of darkness to the state of affairs that expose the war that is raging. In the middle of pressing situations, the darkness can swell and envelope our rational thoughts and perspectives. The Enemy's desire is to veil our eyes tangibly and intangibly. The unrefined emotions of darkness can attempt to caress your senses dull when you feel in the middle of a soul war. The unrefined emotions of darkness need the refinement of a king. We need to open wide the door for the King of Glory to ride in to rescue our hearts. "Lift up your heads, O gates, and be lifted up, O ancient doors. That the King of glory may come in! Who is the King of glory? The Lord strong and mighty, the Lord mighty in battle. Lift up your heads, O gates, and lift them up, O ancient doors, that the King of glory may come in!" (Psalm 24:7-9).[33]

We start by defining the darkness of what is at war in our lives. We need to define those "ancient doors" of war we have locked tightly and hidden beneath the thorn-heavy garden of our souls. We need to get in to a position to see, hear, and receive from God. We need to be equipped to operate from Christ's perspective, becoming capable of battling with lifted heads alongside our strong and mighty warrior King. Seeing, hearing, and receiving from your

Father as you perceive His Presence in your circumstances is an attribute of a daughter becoming all glorious within. These are the tools that will ultimately give us the ability to learn, receive, and respond regularly to the King's voice, regardless of our life circumstances.

Any phrasing that could have the power and potential to give us ownership of the darkness is no good. *My* issues and *my* darkness don't exist. You do not own a dominion of darkness. Period.

A few years ago, my husband brought to light that I kept claiming personal ownership over the enemies on the front lines. One day while talking through some tough trials, he put his hands on my shoulders, looked me straight in the face, and said, "Cari, stop taking ownership of the darkness that is surrounding you. It's not yours. It's not over you. Stop accepting that in your life. You are a child of God and have the power to step into His marvelous Light, but it's your choice. Step away from owning the darkness, and don't take it on as your own." Boom goes the dynamite.

> This is the message we have heard from him and proclaim to you, that God is light, and in him is no darkness at all. If we say we have fellowship with him while we walk in darkness, we lie and do not practice truth. But if we walk in the light, as he is in the light, we have fellowship with one another, and the blood of Jesus his Son cleanses us from all sin. (1 John 1:5-7)[34]

As much as we try, we cannot produce light. However, because Christ dwells in our hearts and lives, we have

access to the Glorious Light as well as the power to use it to illuminate ways that the dark presses against us.

> He who is the blessed and only Sovereign, the King of kings and Lord of lords, who alone has immortality, who dwells in unapproachable light, whom no one has ever seen or can see. To him be honor and eternal dominion. Amen. (1 Timothy 6:15-16)[35]

I love the language Paul uses as he writes to Timothy. He focuses on the glory of God, so the corresponding smallness of Timothy's opponents might be revealed. Paul coaches Timothy by reminding him God's power and authority supersede his present conflict, confusion, corruption, temptation, or the dominion of darkness that is rising against him. That's what we want to do: push the unapproachable radiance of the Light of the King and discern the diminutive power of the darkness.

My friend Kirsten, who lost her darling Lauren, is rising, battling, and focusing on the Glory of God. She would be the first to say it's a battle every day, and some days are easier than others. A piece of her heart will be unrestored until the glorious reunion she will have in Heaven with her daughter. But she has opened the ancient doors of what is unrestored in this life and is allowing the King to come in and make it redeemed. She wakes every day and clings to the promises of God. "My frame was not hidden from Thee, when I was made in secret, and skillfully wrought in the depths of the earth. Thine eyes have seen my unformed substance; and in thy book they were all written, the days that were

ordained for me, when as yet there was not one of them. How precious also are Thy thoughts to me, O God! How vast is the sum of them! If I should count them, they would outnumber the sand. When I awake, I am still with Thee" (Psalm 139:15-16).[36] She is reaching out to other families battling congenital heart disease. She is remembering her daughter by fighting with the tools of God. She is throwing off the darkness and putting on the Light.

Kirsten and her husband, Mark, have made the courageous decision to fight for the legacy of their daughter by establishing the Lauren Elise Memorial Foundation (www.ilovelauren.org).[37] Its purpose is to support awareness, research, diagnosis, and treatment of congenital heart defects (CHD) in children and to provide for the care and well-being of children affected with CHD and their families.

My friend Ryan is battling alongside Christ and allowing Him to dispel the lie that the darkness will overtake her hopes for abundant life. Through her girls, God has used her and her husband to reach out to other families who may be hurting. In 2009, she and her friend Amy Haas started Hope Link (www.okchopelink.org),[38] which is a support group for moms of children with rare and undiagnosed disorders. In 2010 they started the OKC Hope Link Foundation, whose purpose is to support families through love, prayer, and service. Their desire is to meet families where they are in their journeys with their children and help them to see they are loved and not alone. Ryan believes the King truly called her to Hope Link and its ministries through this word: "The Spirit of the Sovereign LORD is on me, because the LORD

has anointed me to preach good news to the poor. He has sent me to bind up the brokenhearted, to proclaim freedom for the captives and release from darkness for the prisoners" (Isaiah 61:1).[39] Because of her daughters and their legacy, God has called her to love those who are poor in spirit, whose hearts are broken, and those bound in darkness and depression because of life's circumstances.

I am sharpened by her faith as she quotes Romans 8:28, "And we know that God causes all things to work together for good to those who love God, to those who are called according to His purpose."[40] Her commentary on that proclamation stirs my soul. "During our trials, I must remember that God DOES, CAN, and WILL cause ALL things to work together for MY good and for the good of my children. He has our best interest at heart, even though it may not look like it. He causes it all to work out and for all glory to go to Him alone. I cling to that promise because I know He IS good." She resolves to see the King ride in, in all His glory, win the battle and silences the shouts of war from the Enemy. "Though he slay me, I will hope in him; yet I will defend my ways to his face" (Job 13:15).[41] She announces through the megaphone of the Word that God is the Sovereign Lord. "He controls, causes and allows all things; even the bad things. Even the things that hurt." Ryan's message to me regarding her battle raises the fight in my soul as a daughter of God to keep fighting the good fight and allow the King the opportunity to be glorified. "He uses them all for His glory. I find encouragement in Job's life and testimony. Job chose to hope in God and to

trust His everlasting Father, beyond circumstances. One definition of 'hope' is to 'trust.' I choose to trust God and His Sovereignty. I choose this on a daily basis. Sometimes I have to choose to trust, to hope many times throughout the day."

We want to come alongside Christ and allow Him to dispel the lie that the darkness will overcome, overpower, or overtake you. God wants to dismantle and discredit the lie that there is little to no hope of ever getting out of that deep, dark, oppressing war. "Stronghold" is a military term from war. It is where forces hold up in a concentrated and fortified location. Spiritually, a stronghold is any idea that is directly opposed to the Word of God and seems immovable and unchangeable. God wants to lift the fog of confusing circumstances that are veiling your heart from taking the fantasy of your dreams into the activated energies of your reality.

We have to stop taking ownership of the dark, even in our passing language. Anytime you refer to a dark place in your life as "your darkness" or "my darkness," you create a stronghold. Don't give yourself an out just because you haven't used the word "dark." Double-check any language you have used that refers to things of this world. Any of these phrases could fit just as well: my addiction, my problems, my depression, my pain, my stress, or my anger. Please take a second to connect the dots with me in the scriptures I just read. He has transferred us from a domain of darkness into His glorious light (Colossians 1:9-14)[42] and to him be the honor and eternal dominion forever (1 Timothy 6:15-16).[43].

His word over your life destroys strongholds. God wants to blow up the enemy strongholds from the inside out. All of the fortress disintegrates with His Word, and His Light invades and liberates hope and victory.

I'm not suggesting we walk around with a false sense of reality and just ignore our problems because, "Cari said we shouldn't talk about the darkness of the problems that surround us." I'm challenging us to look at the dark places of life alongside the Light of Christ, not with our limited human nature alone. I am suggesting we rise above the war line to see the King standing atop the hill. I think God desires to challenge our thoughts, so we stop assigning it to the wrong place. It's not yours to pick up, and if you don't pick it up, it won't overwhelm you. The lie that you *own* your darkness or war will only keep you chained to guilt, shame, abandonment by God, and feelings of unworthiness.

He has transferred us from a dominion of darkness and eternal condemnation into His glorious Light, and that means the eternal light of glory is what now has full, complete, and uncontested dominion in our lives forever. That is our identity: an eternity of glorious Light not despairing darkness. The dark might press against us, but it cannot be in us if we have given our lives to Christ. The dark you have experienced, whether intentionally or unintentionally, does not have the spiritually legal right to take over any residence in your life. Unless you give it a right. "In the world you will have tribulation. But take heart; I have overcome the world" (John 16:33).[44]

49

The world promises to give us tribulation, dark circumstances, and weapons that threaten to take us down. The darkness comes in uninvited at times, and as a weapon of darkness, it could come in the form of isolation, heartache, loneliness, depression, boredom, laziness, an unhealthy soul tie, rejection, addiction, or despair that threatens to stay. How they *remain*, how they stay and war against you, is directly related to our *response* to them. Not the response you show everybody on Sunday morning, when you "put the face on" or when you are hanging with your good Christian gal pals, but when you are in the quietness of your own heart. I'm talking about when your pretty little head hits your Egyptian cotton pillow at night. What voice is putting you to sleep? Remember, a true, enduring, becoming-all-glorious-within-beauty has to radiate from the inside out, and that includes the voices in your head. It won't last if you work from the outside in. Allowing God the space to have victory over our soul sicknesses is what gives us peace and healing from the inside out. In the book, *The Rest of God*, Mark Buchanan states, "Physical sickness we defy, but soul sickness we often resign ourselves to."[45]

Feeling that you are alone and left to die in the darkness can be very real. There is pain in this world deeper than I could even attempt to give explanation for or relate to. Unthinkable damages are inflicted on the daughters of God every day that I can't possibly entertain without being moved to tears. I know on a broad level there are hurts this world has caused that can make our souls nauseated with heartache and anguish. And for that very reason, God has to reign as

King. If we dwell on dark times without committing them to the King's care, it could swallow us up like a gruesome monster. Living as timid fairy princesses isn't going to cut it in the Kingdom of God during this generation of the world. "For God has not given us a spirit of fear, but of power and of love and of a sound mind" (2 Timothy 1:7).[46] The King is calling His daughters to rise up, fight in the dark, and give Him the valiant opportunity to rescue them.

"Awake, O sleeper, and arise from the dead, and Christ will shine on you!"(Ephesians 5:14).[47]

We can manage, position, and control every painful experience that ultimately prevents our healing. Or we can step into becoming glorious and start to exalt Him as the King with all authority over the dominion of darkness. If we are brave enough as daughters to stop emasculating God so that we can feel all warm and fuzzy, we'll light the world on fire. I believe with every fiber that God wants to do something extraordinary with His daughters in this generation. I believe it so much that I claim the Song of Victory proclaimed by the prophetess Deborah over my own daughters' lives. "March on, my soul, with might!" (Judges 5:21).[48] I say it over them every night. I couple it with Psalm 16:5-6: "May the Lord be Shelby and Ainsley's chosen portion and their cup; may He hold their lot secure as daughters. The lines have fallen for Shelby and Ainsley in pleasant places; indeed, Shelby and Ainsley have a beautiful inheritance."[49]

There are equally challenging and strengthening scriptures I speak over my son; however, I want you to

hear how important it is that we claim strong victory for our daughters. The daughters of this generation strive to be pretty, yes, but they also need to be strong from the inside out.

I'm never going to stop telling the valiant story of my redemption and rescue by the King. I'm going to shout about it with all the voice I have to anyone that will listen. I'm going to intercede with all that I am for the generation of daughters to come. I am going to yield all that I am, by God's grace, every day to become healed and whole from the inside out, and I am raising my children to light the world on fire with the Love of Christ. However, I'm not immune to the fact that "in this world you will have tribulation" and that, specifically speaking about my girls, as daughters of God, they'll need a lot more than pixie dust Christianity to survive this world and to change it. They'll need tenacity. They'll need might. They'll need constant reminders that they are heiresses to a beautiful inheritance. I want them to be so spiritually conditioned that they can fight in the dark. I'm not saying I'm raising spiritual army rangers that are Bible drill robots. I'm raising my daughters to be tenderhearted and to have hearts that overflow with the bounty of the fruits of the Spirit. I want them to know how to use their spiritual weapons when a weapon of darkness starts to creep up. Just learning what the armor of God is in Sunday school isn't going to help you if you never put it on. The next generation of Christianity isn't going to be a day at the spa. "But realize this, that in the last days difficult times will come. For men (and women) will be lovers of self,

lovers of money, boastful, arrogant, revilers, disobedient to parents, ungrateful, unholy, unloving, irreconcilable, malicious gossips, without self-control, brutal, haters of good, treacherous, reckless, conceited, lovers of pleasure rather than lovers of God" (2 Timothy 3:1-4).[50]

I want you to be empowered to let God fight for you in the dark. It is one of the biggest hurdles to jump as you become all glorious within. But the dividends of Victory are tenfold. The best soldiers don't question authority, and they don't learn how to fight with pink pillows. They stand ready, and they know how to use their sword and other weapons. "You, however, continue in the things you have learned and become convinced of, knowing from whom you have learned them; and that from childhood you have known the sacred writings which are able to give you the wisdom that leads to salvation through faith which is in Christ Jesus. All Scripture is inspired by God and profitable for teaching, for reproof, for correction, for training in righteousness; that the man (or woman) of God may be adequate, equipped for every good work" (2 Timothy 3:14-17).[51] The King will be coming in as the Valiant Warrior to rescue His daughter, His heiress. The King wins the whole kit and caboodle. God just wants us to get to a place where we can use the offensive weapons we've been given. And the biggest offensive weapon we have is the sharp Sword of God's Word. Start digging in the Bible for truth, victory, and healing. Don't be intimidated by what you don't know; just start. Ask others who have gone before you what they did while becoming all glorious within in the midst of darkness. The

King is big on equipping and empowering His daughters, not just giving us handouts. "He trains my hands for battle, so that my arms can bend a bow of bronze. Thou hast also given me the shield of Thy salvation, And Thy right hand upholds me; and Thy gentleness makes me great. Thou dost enlarge my steps under me, and my feet have not slipped" (Psalm 18:34-36).[52]

Without a deep and unshakable connection with God as the Sovereign Loving King and your identity as His daughter fully intact down to the depths of your knower, disruptions in the relative peace of your life will shake you to the core. It will give the Enemy of your soul the potential to steal, kill, destroy, and derail you from the process of becoming all glorious within. You can know of the role God plays as your provider, redeemer, comforter, and friend and never know the expression of Him as King. The King created you, the King is your Father, and you are anointed as His heir, princess, and a daughter who is all glorious within.

Cleaning up the war-torn landscape of our hearts can seem daunting. The dream of lush green valleys of peace and grace seem both idealistic and completely unrealistic. But the Truth is that the King can and will clean up the battlefield, one piece of emotional shrapnel at a time. The sun will rise above the darkness of war, and healing will come; it will surely come and clean us from the inside out. "Your light shall break forth like the morning, your healing shall spring forth speedily, and your righteousness shall go before you; the glory of the Lord shall be your rear guard" (Isaiah 58:8).[53]

There is no fairy godmother with a bag of gold pixie dust to sprinkle over your circumstances and fly away. No, let's get really honest here. In this generation, fairy dust faith isn't going to fix anything. Not going cut it. But we do have a Book—a Sword—that is our sharpest offensive weapon. Studying the Word of God gives us a depth of heart that can withstand the attacks and inevitable hard life and walk graceful and strong as a daughter of the King. That's a real princess. That's the kind of princess I want to be, and I want my daughters to be.

CLEAN

The screeching sounds of a wind scream like a harsh siren, the darkness closes in, and the silence resonates through the air only for a moment before the calamity of a thunder-like runaway train blows hard overhead. The clamor of a passing storm is piercing, violent. Wheat fields are shredded by the thick arm of a tornado, and the lives laid bare by the open plains. The dust settles and exposes disheveled piles that formerly stood as sturdily built houses. Only the foundations remain; everything else gone.

At times, our spiritual-life houses can feel wasted in the path of an F-5 tornado. Relationships are torn to shreds. Changes rip us from the foundation. Losses pierce us with emotional debris. Thoughts in the aftermath could include, *Where in the world do I ever start to clean up this heart mess?"* The damage of warring through life seems too hard to look at head-on. There are too many unraveled and disheveled life piles to go through. The emotions that it would bring up ... well, we just don't have time to deal with all of that. We have kids to take care of. We have work to go to, school to attend,

houses to clean, friends to support, and organizations we are responsible for helping. We can't take time to have God heal *us*. The mess is too great; the energy required would be too much. At times, all you have energy for is to wake up, brush your teeth, get dressed, and sleepwalk through your day—only to do it all over again the next day. The emotional toll that is paid for cleaning up the war-torn areas of our life can seem so overwhelming that deciding to push them aside gives the illusion of being easier. Claiming we have dealt with them enough and leaving a small pile of unredeemed life can't hurt us, or anybody around us, is a persuasive argument. I would like to suggest that by pretending not to deal with the cleanup and skimming right over life events as they blow across the landscape of our realities, actually does mean we are dealing with it. The point is not whether we are dealing with the damages that surround our hearts. It is a matter of whom we are dealing with over the damages. Who are you trusting to clean it all up?

There are times we deny God the right to clean up places in our hearts that have been shredded by life. Not because He isn't capable, but because we are intimidated by what might be required of us to get it clean. My husband had a football player whose home was wiped out by a real tornado. They stood, as a family, over the foundation slab covered with a soaking pile of what used to be their home, their memories, and their life. They couldn't help but ask, "Where do we start?" Before they could rebuild, they were going to have to clear the land. And that mountain of debris wasn't going to clear itself. They were going to have to clear it. Cleaning

the debris of our hearts can feel the same way. When I sat in that snowy Walmart parking lot, I didn't want to work; I just wanted it fixed. I didn't want any more emotional pain, even if it meant healing. I just wanted life fixed. I wanted more than just the twelve-step "doer" program. I needed to fix the messy rooms of my life. I might have said to myself that I didn't want to clean out all the "rooms"; it just meant I didn't want God to clean out all the "rooms."

Before surrendering in that snow-covered parking lot, I was a grouch to be around. I lived a watered-down faith, because I didn't feel worthy to have a voice. I used insecurity as a blanket I could cover up with. I defined and dismissed every person who disagreed with me, and I lived every day accepting all the lies the Enemy told me. All the while, I maintained strength enough to put on my good girl Christian mask and play my role. I was "dealing" with my mess just fine.

Guess what? Even if you shut it off and pretend not to see the mess, the dark places in your mind and heart that remain unredeemed will still offer you opportunity to deal with it. It just looks a little different.

So you don't want to clean out or deal with the pain of relational baggage you might have. You are aloof to others, because you don't want to get hurt. Guess what? You're dealing with it. You're just not dealing with God.

You don't want to deal with the pain and rejection you have felt or received from the church. Those hypocrites don't deserve your time. Instead, you church hop. You sit around just waiting for the Body of Christ to offend you and then

you blame God and label everybody else. You're dealing all right. Just not with God.

Maybe past mistakes you view as failures hunt you down at every turn, and you can't stand the pain long enough to get to the bottom of it. So you bail every time you think you might mess up, somebody gets close, or someone asks you to give more of yourself. Guess what? You're dealing—just not with God.

What about the cycle of offenses you are in right now? You manage and clothe them as just a part of "your journey". You tell and retell the offenses that have been made against you, but you have never been able to let them go. You victimize yourself, but when a true friend tries to step in under the leadership of the Holy Spirit and help you clean it out, get you help, or support you in truth and love, you get defensive and reject true victory. You're dealing with it – just not with God. (Obviously, if you are being physically abused you are a victim, and you need to get help immediately.)

My husband and I actually love to have garage sales. There is nothing like a good house gut-out, a few bucks in your pocket, and usually a fairly good lemonade stand. We will save and recycle our junkyard treasures for multiple garage sales. Eventually we'll come to that realization that some stuff has finally run its course. Somehow I'm offended the stranger standing in my garage doesn't value my circa 1998 college fraternity date party T-shirt or the braided belts I held onto for an embarrassingly long time the way I think she should. I have to come to terms with the fact there is

finally no more value in our garage sale junk. We can no longer squeeze another dime out of those junkyard treasures. It's time to let 'em go. Time to just get rid of 'em.

Dave Ramsey puts it this way, "You can wander in to debt, but you can't wander out!"[54] You could say it this way: you can wander in to sin and darkness, but you can't wander out. You have to get busy cleaning and not just brush things under the carpet so you can't see them anymore, or spot clean the dishes. You have to remove all the dirt and all the grime. You have to do it the right way and all the way to be truly free from the inside out.

I love how Snow White cleans a house. She rolls up her sleeves, sings a happy song, and cleans the seven dwarfs' home, leaving no stone unturned. She has decided to do a healthy "house gut" and rid them of the junk that is creating must and mildew. She opens wide the doors and windows and invites the animals of the forest to join in. The birds are chirping, the animals are cleaning ... wait? What? The animals are cleaning? The squirrels are sweeping the floor, and the birds and deer are washing the dishes and doing the laundry![55] That right there is the kind of stuff you could take on the road and make a few bucks with.

But that doesn't satisfy ole' Snow White. No, she is a woman who knows what she wants and how she wants it done. She wants it done right. No halfway cleaning for these little critters. She even brings her singing to a halt and in the most congenial voice says, "Oh no, no, no. Put the dishes in the tub." The animals had just been busted and caught in the act of spot cleaning the dishes with

their tongues and drying them with their tails. That is not "Snow White glove" approved. Then she is like a mom with eyeballs in the back of her head and catches the squirrels trying to sweep the dust under the carpet, "Uh, uh, uh. Not under the rug!" Continuing on in the most virtuous voice, she melodiously sings, "Let's whistle while we work! Lalalala!"[56] She was on it!

Snow White wanted it done right. If you just sweep that bitter, angry, disappointed, dark heart under the rug, it will come back. You can keep putting on your mask to hide the smears and smudges of life. The war it will wage on you will come back tenfold. I know, because I tried it. The mask will only cover what you push under it, and it can only hold so many unredeemed relationships, emotions, and roles. If you just try to manage and "spot clean" that dark patch, it gets all over the house of your heart again the second the rug of circumstance moves. I know, because I tried that, too.

Growing up I spent many Saturdays doing yard work or some other sort of "clean out" project, and all I wanted to do was get the job done as fast as possible. My brothers and I would try to breeze through our work and just toss stuff wherever. My dad was on to us, though, and he had eyes in the back of his head. Growing up, I often heard my dad say, "If you're going to do something, do it right, and do it all the way."

Depending on your age, you might try the "But I am young, and everyone needs to give me a chance to just be young and learn from my mistakes. I mean, I think I should have a

little wiggle room on the 'wisdom and understanding' thing?"
Yeah, you could say that. I've tried that, too. When my coach
man and I were dating, I tried to break up with him, because I
knew I was so in love with him and was scared. When he said
I was being immature, I actually responded with "Well maybe
I just want to be immature, okay!" Nice line, Cari.

Is that so off base with what we say to God when He is
prepared to take us to that higher place of glorious living?

What if we, as Christ's daughters, decided to just do it?
To be unafraid to acquire wisdom in the darkness, acquire
understanding, and come to a revelation of where God wants
to showcase His Light and then we acted on the Truth that
is revealed. Please do not look down on yourself because of
your age or whether you are just starting your journey with
Christ or have been walking for a lifetime. Today is a perfect
day to start becoming all glorious within and clearing a path
for the Lord to do a fresh work.

> Acquire wisdom! Acquire understanding! Do not
> forget, nor turn away from the words of my mouth.
> Do not forsake her, and she will guard you; Love her,
> and she will watch over you. The beginning of wisdom
> is: Acquire wisdom; and with all your acquiring get
> understanding. Prize her, and she will exalt you; she
> will honor you if you embrace her. She will place on
> your head a garland of grace; she will present you
> with a crown of beauty. (Proverbs 4:5-9)[57]

> Therefore do not be foolish, but understand what the
> will of the Lord is. (Ephesians 5:17)[58]

Let no one look down on your youthfulness, but rather in speech, conduct, love, faith and purity, show yourself an example of those who believe. (1 Timothy 4:12)[59]

And it shall be said, "Build up, build up, prepare the way, remove every obstacle out of the way of My people." (Isaiah 57:14)[60]

Another expression for the word "understanding" could be that we want to "come into a revelation." We want to come into a revelation, an understanding, of Jesus as we journey toward becoming all glorious within. That understanding or revelation is what begins clearing and cleaning out our heart landscapes.

We are called to be salt and light, and not when we grow up or get it all cleaned out. We are called now!

For this commandment that I command you today is not too hard for you, neither is it far off. (Deuteronomy 30:11)[61]

You are the salt of the earth. (Matthew 5:13)[62]

Mary was a teenager (Luke 1:26-45),[63] David was just a boy when he was anointed (1 Samuel 16:1-13),[64] and Esther was just a girl (Esther 2:1-20).[65] Abraham was one hundred and Sarah was ninety when Isaac was born (Genesis 21:1-6).[66] Noah was six hundred years old when the flood came to earth (Genesis 6-9).[67] Do not put off the obedience of becoming all glorious within any longer. And that goes for

those who feel past their prime. Don't get stuck in the rut of having lived a certain way too long, so you might as well just ride it out. No! I say emphatically, no! In Jesus' Name, let God's mercies be new every day (Lamentations 3:21)[68] and start fresh! Clean your heart house now, and do it right. Let's deal with God and not just with ourselves as we become all glorious within.

Don't get overwhelmed. Just get started.

My mom always says when cleaning up a mess, just start on one side of the room and work your way around. I'll start on my corner, if you will start on yours.

I want the inconsistent areas of our lives—the darkness, strongholds, inner vows, blame, offenses, victimization, unforgiveness, bitterness, or fear—to be cleaned up and healed so absolutely that people don't have to even ask if we are a generation that is acting like Jesus. They'll just know. Those daughters right there are walking like their daddy, the King.

My dad has big strides when he walks, and he walks really fast. I can remember trying to keep up with his strides when I was a little girl. It was hard, because I was really little, and my dad was really tall, and my steps were not near as big or fast as his. But I just kept walking. He didn't slow down. I never got the height to have his same strides, but I sure got fast. What is funny is that people who know me and my dad tell me all the time that I walk just as fast and furious as him.

I like that. I want to walk like Jesus. I want to walk like Jesus with you while you're walking like Jesus.

> Moreover, I will give you a new heart and put a new spirit within you; and I will remove the heart of stone from your flesh and give you a heart of flesh. (Ezekiel 36:26)[69]

> To open their eyes, so that they may turn from darkness to light and from the power of Satan to God, that they may receive forgiveness of sins and a place among those who are sanctified by faith in me. (Acts 26:18)[70]

Trust God to do a proactive cleaning in your life. Swing open the doors to the rooms that are dark, inconsistent with God's Truth, or weaknesses that haven't been partnered with the power of Christ and ask the King where He is in those situations. Ask Him how He desires to make you all glorious within as you clean.

God's conviction to begin a fresh work of becoming all glorious within is specific. A small voice comes in to your head one day that might sound a little like this: "This [you fill in the blank] addiction is really holding you back. You don't have to have it in your life. I love you enough to help you overcome it."

Ask Him to reveal the Light, and Trust His Hand that with every surrendered pearl of your heart, the Glorious Light is exactly where He is leading you. The Lord desires to restore the broken Eden of your heart. "And they will say, This desolate land has become like the garden of Eden; and the waste, desolate, and ruined cities are fortified and inhabited" (Ezekiel 36:35).[71] There are promises to be

had, prophesies to be fulfilled, and God-sized dreams to be accomplished, but we have to start responding to the darkness in a new way. Remember, things will rise up as weapons that have the desire to remain in our lives if we don't proactively seek God. We have to be consistent about dazzling the darkness and allowing the King to clean out the messes in our minds and hearts. We have to start allowing it all to become dazzling.

Prayer is one of our greatest offensive weapons to partner with your Sword of Truth, and the best way to start the conversation is to do a spiritual spring cleaning. Prayer is the way in which we take our plans, lives, and desires to God and end up leaving with the perfected will and peace of God situated in our hearts. Prayer has been a lifesaving offensive weapon for me. Prayer is cleansing. Take time before you move on to the next chapter to pray this prayer.

Warfare Prayer from for the Family, by Sylvia Gunter

Father, I bow in worship, praise, and thanksgiving before you. I surrender myself completely to you. I am covered with the blood of the Lord Jesus Christ as my protection. I am submitted to God, I resist the Devil, and he must flee. In the name of Jesus, I bring the blood of the Lamb against all the works of the Enemy.

True and living God, You are worthy to receive all glory and honor. You love me; You sent Your Son to die as my substitute; You completely forgave me through Him; You gave me His perfect righteousness; You

made me complete in Him; He won total victory for me on the cross and in His resurrection; you adopted me into Your family; You assumed all responsibility for Your provision for me is complete. Blessed Holy Spirit, I live and pray this day in complete dependence on you. Pray your prayers through me.

I have mighty spiritual weapons. I choose to stand aggressively in the full armor which is Jesus Himself. I claim all His victory today. I am now seated in heaven with Him. In Jesus' name, the Enemy is under my feet. In Jesus' name, I tear down the strongholds of Satan and reject all his plans formed against my body, mind, will and emotions. I reject all his schemes of hindrance, insinuation, accusation, temptation, lies and deception. Show me where I am giving any ground to him, and cleanse me from every foothold.

The Word of God is true, and I will obey you and abide in you. I put off the works of the old man, and I stand in the victory of Jesus to cleanse me from the flesh and enable me to live above sin. I put off all _____ (my greatest struggles—selfishness, fear, doubt, lust, etc.) and put on _____ (the new nature of holiness, righteousness, truth, courage, strength, faith, etc.)

You blessed me with all spiritual blessings in Christ Jesus. I welcome the Holy Spirit living in me to fulfill your will. Transform me and fill me with your love, joy, peace, patience, kindness, goodness, faithfulness, gentleness and self-control.

I stand on victory ground for today. I claim all the work of the cross of Jesus, His resurrection power, His ascended authority, and Pentecost for all my victory. You are Lord of all my life this day.

In Jesus' name, Amen.[72]

6
FLESH

As I flipped through my Bible, a little frustrated at the writer's block I was experiencing in trying to communicate our next step in our process of becoming, a narrow sticky note fell out onto my desk. The sweetness of the surrendered words scribbled out on that hotel notepad empowered me and propelled my pen to scribble fast and hard the passion the Lord has for our becoming. The words are written by a teen who attended a conference I spoke at a couple of years ago. Her words of courageous surrender strengthen the story God is scripting for us within these pages.

> What I realize now, God is taking my life and ripping it apart to make me strong; show me his power. He is going to use me for something great and He is going to need me strong when the time comes. He is gonna use me; I want him to use me. Thank you for helping me see that. I'm not going to fight it anymore. I'm gonna embrace it.

As daughters, we are indeed becoming. We are evolving and being re-created, regenerated as beautifully courageous

butterflies anticipating our release to become world changers. Once we have become a daughter of God, we are in Christ. We are redeemed, made whole, cleansed, and found in His righteousness. Once we surrender our lives to Christ, we are put in right standing with God. However, we have to step intentionally into the protection and provision of the blood of the Lamb. The blood of the Lamb is your Shield of protection from the destructive intent of the Enemy to take captive your heart. Our Father's passion for our becoming was wondrously shown through the steadfast love of Jesus. Jesus was the first "becoming." When we come in contact with the intimate person of Jesus, we come to a deeper reservoir of love than our fairy tales can contain or our most passionate heart's desires can describe. We have come to Jesus, to the person, to the original and most important Becoming of the King of Kings and the Lord of Lords. We have come to the crossroads of officially being transformed from the inside out. There is always tension in change. Leaving that addictive generational iniquity to pursue freedom will be a change that proves harder than you think. Unshakable resolve to wake up and praise God when the new job you have been begging to have doesn't come will be sacrificial and often leave you sweetly broken. Trusting God when you have lived a life full of untrustworthy relationships will be difficult. The temptation to assign human traits to a Holy God will flood your carnal flesh fast and often. Depression may continue to haunt your steps. Pushing back flesh-filled lies will require an endurance of strength you won't have on your own. Fighting on as cancer rips through the threads

of your life will, at times, feel excruciating; you will often be battle worn. Standing firm in your faith as those around you ridicule your surrender to Jesus will leave you feeling lonely more often than I would like to admit. That sweet teen girl who wrote me that note will need Holy courage to continue stepping out into glorious living, because it won't come easy.

All those sentences leave out a crucial part of our becoming. It is really the only part of our becoming that seals the deal, makes it real, and allows glorious living to take deep root. If we are left alone to re-create the perfected creation of Eden within our hearts, we will fail. We will give up. We will give in. We will walk away. We will stop our becoming just short of realizing the dream of flying off, full to the brim of abundant life, into our God-designed destiny as a gloriously beautiful daughter of the King. Our Sovereign King knows how hard it is for us just to live, and He knows how doubly hard it is for us to live with abundant life. He saw the brokenness of Eden. He saw Eve stop short of glorious living. He knew what it would take to re-create our hearts. He knew it would take a Savior. He knew it would take His Word coming down to earth in flesh form. He knew it would take Jesus.

> And the Word became flesh, and dwelt among us, and we beheld His glory as of the only begotten from the Father, full of grace and truth. For of His fullness we have all relieved grace upon grace. For the Law was given through Moses, grace and truth were realized through Jesus Christ. (John 1:14, 16-17)[73]

Jesus became what we could never become alone. Jesus, the very Word of God, became flesh and dwelled among us. He became sin, struggle, heartache, poverty, despair, depression, and loneliness, and was sacrificed as broken bread for all that we could not atone for. And with that becoming and submission to the will of the Father, Jesus became the embodiment of God's glory, grace, redemption, and peace. God's love became beautiful, approachable, and intimate through the sacrifice of His Son, Jesus. It became perfected fulfilled prophesy. Jesus became Love in the highest form.

I love to read the words of Jesus in John 17 as He is dying on the cross and expressing the power of His becoming and, in turn, how His becoming will actually be our becoming.

> When Jesus had spoken these words, he lifted up his eyes to heaven, and said, Father, the hour has come; glorify your Son that the Son may glorify you, since you have given him authority over all flesh, to give eternal life to all whom you have given him. And this is eternal life, that they know you the only true God, and Jesus Christ whom you have sent. I glorified you on earth, having accomplished the work that you gave me to do. And now, Father, glorify me in your own presence with the glory that I had with you before the world existed. I have manifested your name to the people whom you gave me out of the world. Yours they were, and you gave them to me, and they have kept your word. Now they know that everything that you have given me is from you. For I have given them the words that you gave me, and they have received them and have come to know in truth that I came

from you; and they have believed that you sent me.
All mine are yours, and yours are mine, and I am
glorified in them. (John 17:1-8, 10)[74]

Walking independently, rejecting a proactive grown-up relationship with the King through Salvation, will keep you under the stubborn authority of the weakness of your own flesh. You will never have the power to offer grace-filled forgiveness to others who have wounded your heart too deeply to articulate. You will never have depth of strength to wake up the morning after the funeral of your loved one. You will never have the physical supremacy to overcome disease. But the authority and glory and overcoming power of a Holy and Perfect God became flesh and dwelt among us! For the good of God's people and the manifestation of His glory Jesus was given authority over all flesh (John 17:2).[75] Sweet daughter of God, that means Jesus has authority over everything you will face! Not only does Jesus have authority over it, when He became our salvation and redemption, He transferred His glorious light to you and gave you the power and authority to live an overcoming life through Him. That is good, good news for daughters who have submitted to the creation process of the King. Jesus creates beautiful things out of us! Because He became, you will indeed become!

Jesus even takes the glory of our becoming a step further as He offers a final prayer on the cross of redemption: "Sanctify them in the truth; your word is truth. As you sent me into the world, so I have sent them into the world. And for their sake I consecrate myself, that they also may be sanctified in truth" (John 17:17-19).[76]

"And the Word became flesh and dwelt among them" (John 1:1).[77] Jesus became the touchable expression of God's spoken Word. As you allow Jesus to infiltrate more and more of your heart and soul, you, dear daughter, will become the tangible expression of God's spoken Word to those you are around. Our effectiveness is not based on our efforts alone but on God's habitation, His indwelling, His manifestation in the deepest part of our hearts. Abiding with Jesus is the key that unlocks the door over and over again. "Abide in Me, and I in you. As the branch cannot bear fruit of itself, unless it abides in the vine, so neither can you, unless you abide in me" (John 15:4).[78]

I was given the privilege of going into a minimum security prison to teach the Word for one hour to twenty female inmates. I never hesitated in saying yes to the opportunity, but as soon as I did, my soul started to back up. I thought I had nothing in common with those women and immediately felt they wouldn't want to hear anything I had to say.

If you have seen me, you know I would never pass what my husband refers to as the "eye test," which is a coaching term used to describe the stature of a potential recruit. I am only 5'3" with heels on and have a fairly tiny frame. I was a thirty-year-old woman who has been told several times I don't look a day over seventeen (which I decided a long time ago to take as a compliment—if you can't beat it, you might as well agree with it). I'm girly to the last detail of my being, and to top it all off, I have a very high-pitched Minnie Mouse voice. Rolling into a women's prison to lay

down the Word to some inmates was a stretch beyond my comfort zone, to say the least.

As we moved past the initial security checkpoints, we emerged into the holding pod area and then into a specific pod that held these twenty precious women. While my introduction was being made and as I approached the Throne of Grace in the quietness of my own heart, my confidence waned. I viewed the shadows of their worn faces and felt so inadequate. During that quiet prayer in my heart, the Holy Spirit revealed His message for these daughters, and I was filled with a Holy courage.

Gideon Bibles were passed out, and the women sat staring at me, waiting. Much to my surprise and relief, as soon as I asked them to bow their heads to pray and spoke the name of Jesus, the peace and protection of the Holy Spirit spread over that prison pod.

I proceeded to spend an hour teaching the basics of who they are in Christ and presenting the Gospel as a place of grace, love, and forgiveness. I expressed there was great power in surrendering to the Love of Christ. In Christ they are more than conquerors and are capable of being great overcomers. In that small room of women, addictions were everywhere. With the addition of meth and alcohol to abuse and neglect, strongholds were prevalent. Women were battling addictions handed down from generations of rebellion.

During the time of teaching, there was incredible discussion of what Christ really says about them. As the hour was closing, a woman who couldn't have been more than twenty-five but looked like she had wearied a lifetime,

sat in the back with tears rolling down her face. I had noticed she had gotten up several times to go back into her cell. I asked the women seated around the tables a final question, "How do you feel now having just heard who Christ says you are and that you are His daughter if you have accepted Him as your Savior?" The woman in the back shot her hand up and shared that what had been spoken over her life by nearly every adult relationship she had ever known was that she was a mistake. As tears welled up (and more than a few of the other inmates quietly tried to hide their own brokenness over her confession), she went on to give God the glory for redeeming her from within the walls of this prison. She said hearing an outsider's voice say God viewed her as a worthy daughter and heir to a kingdom broke down all her walls and filled her heart with hope that is starting to replace the years spent hearing voices of unworthiness. Her outside circumstances of gray prison walls and an orange jumpsuit did not match the changes being made inside her heart just yet. But if she continues to stay connected to the Source of that voice of worthiness in her life, it won't be long before she sees outside evidence to her becoming all glorious within.

I left that evening changed forever. Those women don't have the luxury of hiding behind pretty, tidy lives. They recognized their sin, they recognized their total soul depravity without Christ, and although they presented a tough exterior, their hearts were as tender as can be when the name of Jesus was spoken. They were desperate and dependent on God's help and healing.

There was nothing I said in and of myself that brought an ounce of healing to those women. Only the deep places of the Holy Spirit can call out and heal the deep places of your heart. Be persistent when climbing that mountain of life rubble and pursue Christ. Be desperate. Be dependent.[79]

> Jesus said, "The words that I speak unto you," not the words I have spoken, "they are spirit, and they are life." The Bible has been so many words to us— clouds and darkness—then all of a sudden the words become spirit and life because Jesus re-speaks them to us in a particular condition. That is the way God speaks to us, not by visions and dreams, but by words. When a man (or woman) gets to God it is by the simplest way of words.[80]

There is importance in hearing the spoken Word of God. There are eternal deposits made when we again and again verbalize the promises and allow the Word to become flesh and dwell among us. Start verbalizing the promises of God to yourself and to others. Adjust your language to speak forth grace, mercy, truth, and belief in a mighty and capable God. Fill your home with the promises of God. Frame scriptures, play worship music during the day, post encouragements on the fridge, speak God's promises over your family, be bold in claiming the promises of God. Pray God's Word back to Him; those are perfected God-inspired promises. They will not return void of accomplishing what is promised.

> So shall my word be that goes out from my mouth; it shall not return to me empty, but it shall accomplish

that which I purpose, and shall succeed in the thing
for which I sent it. (Isaiah 55:11)[81]

When you are praying and speaking God's Word, your words are not getting in the way. As you speak those promises, you climb up. You rise above the clutter in life that threatens to crowd out His voice. You begin to overcome and live out a life of faith. It positions you as a daughter before the Father, hearing worthiness, power, authority, promise, hope, vision, courage, and strength to endure as you strive toward becoming all glorious within.

> I'm not talking about being religious, saying "church" words, speaking "Christianese," or quoting "catchy phrases" without any power accompanying them. I am talking about praying in a way that will accomplish results. I can tell you how to swim, I can describe the water, and I can teach you all the correct moves, but at some point you are going to have to get in the water. Once you get into the stream of God's Spirit flowing through you as you pray, you are going to find yourself not only staying afloat, but also rising to the top of each wave of life that would normally overwhelm you.[82]

Pursuing a becoming that grows from the inside out gives us the proper life perspective. It shifts our focus from what we are not to what we are in Christ. We rise, because we are full of God's power and vision for our lives. We become ready to receive who we are in Christ and what He has prepared for us as individual daughters. He has perfect

plans for each one of us that He is just waiting to expose lavishly before our eyes.

My friend Amy Newberry is speaking the promises of hope over the marginalized in Oklahoma City through her ministry the Tapestry Project (www.thetapestryproject. org).[83] She has taken the brokenness of homeless, drug-laced, gang-infested neighborhoods and allowed the manifestation of God to revolutionize a community one life at a time. She has a sketchbook full of dreams for community development projects God is bringing to life every day. Her mission is to love the neighbors in these marginalized areas; mobilize resources they might need; push out the drug dealers; push back the gangs that destroy young lives; feed the hungry; create accountability; reach the latchkey kids; establish leadership within the community churches; and offer temporary and permanent solutions to the problems these families face. God's promises are being spoken out through the Tapestry Project's acts of lavish love. God's love is becoming flesh and dwelling among those affected by the Tapestry Project. They are pushing back the darkness and advancing God's kingdom. Amy and her team are speaking promises of hope, love, protection, and a redeemed, healed, and whole future of those who, most of their lives, have felt lost, alone, and left to die, abandoned by the world. But God hasn't abandoned them. He holds their worlds in His able hands. He holds your world in His hands. He became everything you desire to become. Release the victory of His becoming in your life. Allow His becoming to be your becoming.

O Lord, in your strength the princess rejoices, and in your salvation how greatly she exults! You have given her, her heart's desire and have not withheld the request of her lips. For you meet her with rich blessings; you set a crown of fine gold upon her head. She asked life of you; you gave it to her, length of days forever and ever. Her glory is great through your salvation; splendor and majesty you bestow on her. For you make her most blessed forever; you make her glad with the joy of your presence. For the princess trusts in the Lord and through the steadfast love of the Most High she shall not be moved. (Psalm 21:1-7)[84]

7
GOLD

The "Fifty Nifty United States" melodiously echoed through my elementary hallway one exceptional spring evening. The walls were lined with a brood of fourth-graders dressed in various regional costumes. Corn husks, Pilgrim hats, mountain men, waving wheat, and the Statue of Liberty represented the fifty states. We had been divided up into states and were required to make a costume to represent that territory. I was so excited when it had been announced I would be one of the princesses representing an island of Hawaii. I can't remember which island, but I can remember I was assigned the color gold. Gold is a beautiful color. But in my diminutive perspective, gold was not the *most* beautiful color. Pink was the most charming and royal color to any little girl's heart, and at that deep and introspective point in my life, that was exactly how I felt. The pink Hawaiian princess was assigned to my friend. It was definitely an honor to have been selected as one of only eight island princesses, but there was something extra special for my friend, because she was the pink princess.

I remember standing in the hallway on the evening of the show while my mom snapped a picture of me in my gold princess dress and lei made of gold Christmas tinsel. Standing there in that hallway, I grinned from ear to ear. To the naked eye, I looked proud as punch and happy as a lark to be representing my gold island. Yet without even realizing it, I was making an inner vow in my heart that day. I can recall smiling for the picture, while out of the corner of my eye, I looked at my friend in her pink princess dress and thought, with a twinge of sorrow in my moldable heart, *It's okay. I'm happy to be the gold princess. I can be okay that I wasn't good enough to be the pink one. Pink is the best and most lovely color ever, but that wasn't for me. I can accept that I'm just not worthy to be* that *princess.* Mind you, when selecting the colors, the girls, the islands, and so on, the teachers made the selections randomly, and in their minds, no one color, girl, or island was better than the next. The thought that pink was superior came from my own perspective. I was proud of my gold dress, and I was not jealous of my friend at all. She was precious, and I adored her as a friend. But on that day of my life and my own human nature, I was making a personal vow and receiving a whisper from the Enemy of my soul that I was not worthy.

That night, I went out and rocked the show as the best gold princess I could be. I laughed, sang, said my lines, and played my part. No one, not even I, really knew the depth and effect of that inner vow. Feelings of unworthiness didn't stop in the hallowed hallways of Apple Creek Elementary. Feelings of unworthiness whispered defeat to my heart for longer than I would like to admit.

Fast-forward several years into my adulthood. Through the King's mercy He has birthed a ministry, Glorious Daughters, out of Psalm 45:13. As the Lord revealed His heart for me and the ministry through His Word, I have devoured its truth. I have studied it inside and out, read commentaries about it, cross referenced it in every translation, and have had so many intimate moments with the Father over this specific text. It's personal to me. I say all that to represent the amount of time I have meditated on this Word. It is a part of my being, and yet there was a specific word I had missed, and only the tenderness of the Holy Spirit could've cultivated.

During a submitted time of prayer, the Lord revealed His Word in a new way, and the depth of the Holy Spirit cultivated a memory that was tucked deep within my soul. I was talking with my husband after a worship service and relaying the story of the gold dress to him. I told him the Lord had made me recall the random vision of me standing in the hallway and making that inner vow of unworthiness. I recognized I had lived much of my life based on that vow. I had played the part, bowed and accepted applause in life, but had grown dutiful in my heart. I had lived boldly as a servant in God's House but never as an heir to His Throne. Although I was a believer, I had never fully accepted that the position of daughter in His Kingdom was for me.

In the middle of our conversation, I gasped dramatically! I cupped my hand over my mouth and whispered, "I've been missing it!" I quickly scrambled underneath my chair to get my Bible, all the while saying under my breath, "I've been

missing it. Oh have I been missing it all this time?" I was trembling as my fingers flipped madly through my Bible, trying to get to the scripture I had read a thousand times. Could it be I had missed the most important word treasured deep within that scripture? Had I missed it all along?

"All glorious is the princess in her chamber, with robes interwoven with ... gold" (Psalm 45:13). Gold. It was gold all along. As a princess of the King, I have been adorned with ... gold. To say I started weeping would be an understatement. Probably scared my husband a little bit, but those passionate, stinging tears of healing could not be helped. In one moment I had been healed of all the years that inner vow of unworthiness had claimed power over me. I was worthy, and I had been missing it. In that moment of restoration, it didn't mean pink wasn't a royal color. It meant that the King had chose gold for *this* princess. It's not about pink, purple, blue, magenta, or silver. It's personal. The King is personal to His daughters. Only the King could recall that memory in my heart and then connect that memory to the work of becoming He had started in my life based on Psalm 45:13. He had chosen to adorn me with gold, because I was *His* princess. That's far better than any pink Hawaiian princess. The King has intentionally selected you to live as His princess. He has chosen to adorn you with gold.

> The Lord is my chosen portion and my cup; you hold my lot. The lines have fallen for me in pleasant places; indeed, I have a beautiful inheritance. (Psalm 16:5-6)[85]

Please don't accept that you are unworthy; it couldn't be further from the truth. Feelings of unworthiness can prevent us from living out a gloriously victorious life. It can hinder our submission to becoming all glorious within. Feelings of unworthiness can affect more than just one area of our lives. If given enough space, one lie has the power to overtake our lives, especially as women. It can paralyze our entire being for a lifetime and affect decision upon decision. That is why it is so very important to allow Christ complete control over every single space in our heart and life: over our marriages; over what we see in the mirror; over the mundane, everyday moments of our day; over our quiet moments; over our fears; over the past, which seems to chase us around every corner; over addictions that haunt our every moment; and over perceived failures or weaknesses. Every single place the accuser threatens to take our voice and steal our hearts we have to give over to God. Then and only then do we give the King the power to radiate praise and glorious living from the inside out, as well as giving you, daughter of the King, the authority to stand not in your weaknesses but in the perfected power of Christ.

> My grace is sufficient for you, for my power is made perfect in weakness. (2 Corinthians 12:9)

He sees a beauty worth lavishing. He sees His daughter becoming all glorious within. And He is just waiting to personally and intimately adorn you with the royalty and grandeur of the color gold.[86]

The person of Jesus, the very essence of God, placed His feet on this round sphere we call a globe to become a personal and intimately connected Savior in your life. That is the key that unlocks gloriously victorious living, connecting daily with a personal and intimate Savior, spirit to Spirit. It literally looks like you're beginning to view the King as an active, relational, and intimate companion and friend in the ins and outs of your every day.

I love the description that is given in Shannon Kubiak's book, *The Divine Dance*.

> God thinks you're beautiful, but He wants you to be radiant. God made you bright, and He wants you to shine. So He must strip you of your glitter; He must tear away from your fans, and He must take you into a quiet practice studio and teach you all over again how to truly dance. He must groom you for your role on the world's stage. He must teach you to give the glory to Him and to stop striving for the world's approval. At first you may be lonely—the quiet blackness of a studio may seem dim in comparison to the bright stages of the world gave you ... In God's studio ... you will discover that true beauty is in the dancer's heart, not in her costume. You do not need to stand apart from everyone else, and you will never need to ask God to pick you. You have already been chosen. You already hold center stage in His heart. So stop auditioning and dance.[87]

Your authentic worth and beauty are found in the deep recesses of the heart and soul that Christ created. He thought

of you before the foundation of time and had very specific plans for your individual life. He formed you within the depths of the earth. He has a deep love and understanding of who and what you are.

> For you formed my inward parts; you knitted me together in my mother's womb. I praise you, for I am fearfully and wonderfully made. (Psalm 139:13-14)[88]

What happens too often in our lives is that we surrender to what we have decided is the "superior pink," and we no longer see our lives through the lens of our loving and affectionate Father. We only see our life based on our limited natural eyesight. We only hear what other people say about our life, and we only feel acceptance based on the tangible outward "superior success" that we've defined as great. What we don't understand is that kind of success is based on someone else's opinion. It isn't based on a Holy opinion; it's based on an imperfect human opinion.

Yes, it is important that we try our very best at everything we do. Excellence is always important in the life of a believer, as well as receiving love and affirmation from our God-honoring earthly relationships. However, if these things have replaced who and what God says or requires of us, we have stepped outside His authority and are operating without His perfected instruction or blessing. Our relationship with the Lord needs to get a lot more vertical and a lot less horizontal. As a generation, we have become much too horizontal in our relationship with the Lord. As long as we receive the superior blessing or success from others in our horizontal

world, we assume we must be doing something right. If we are not careful and continue to stay submitted to the vertical affirmation or direction from our very Creator, we will be tempted to consult only our best girlfriend's opinions about our lives. And the Truth is that our closest relationships should be those that love us enough to lead us vertically first and then, only after that, affirm us horizontally.

Obedience in life is not based on anything other than our personal, intimate relationship with God. You should be so closely connected with your Creator, your King, regardless of the outside requirements on you. When you lay your head on your pillow at night in the quiet stillness, just you and God, there is peace. After you situate your being in that Truth, everything else will flow naturally from that realization.

When we offer all that God alone has created us to be, the best of every one of our talents and gifts, and then allow Him the opportunity to rise and be glorified, we will see our true worth and identity. When that happens, worship happens. It's automatic. A life fully surrendered and trusting in God can't help but bring praise and honor to the King.

As a whole, we will merely be offering back in full obedience to God the talents, colors, or gifts He has so graciously and generously offered us. It *all* belongs to the King.

Are you a teacher? Teach for God's glory, and offer that as worship to the King. That's a daughter becoming all glorious within. Are you a coach? Coach for God's glory as you become all glorious within, and offer that as worship

to the King. Do you work in the professional world? Work as you are doing your work unto the Lord and then allow that to be a fragrant form of worship to God. Are you a student? Learn with God in mind so that as you grow, you can increase opportunities to worship God and encourage others to do the same. Are you an artist or designer? Create, imagine, and express, and while you're at it, worship the King as His daughter all glorious within! Are you a parent? Train your little ones up with all the Love you have to offer, and show them Jesus! Are you a volunteer? What a beautiful way to express God's heart and worship! Are you a musician? Practice, sing, play, and illuminate your world with beautiful sounds that bring glory to God and ultimately worship the King. Are you an athlete? Compete to bring God the glory.

I love the movie *Chariots of Fire*.[89] It is the true story about a Scottish athlete and missionary named Eric Liddell. He was the winner of the men's 400 meters at the 1924 Summer Olympics in Paris. God made Eric Liddell fast, and when he ran, he felt God's pleasure. He had tapped into the unique talent God had fashioned in him, and he did it to the best of his ability. And while he did it, he worshipped God and brought Him glory for generations to come. That sounds good … bringing God glory for generations to come. Let's be a generation of daughters that does just that. Tap into what it is God has called you to be and be it. Don't be tempted to get distracted by *all* the things you *could* do. Pray and ask God what He has specifically created you for. Get vertical in your conversations about your life and what

you are becoming … then be courageous enough to step out and do it.

My Grammy broke her hip not too long ago, and we went to see her in the hospital. She is tough as they come and did rehab two summers ago on a broken femur. She lives independently and still drives. She's "eighty something." She is a mover and a shaker and has spent her life as a Methodist minister's wife in spirit and in truth. She moves to help. Always has and always will. I mean the woman has places to go and people to tend to! She lives in a semi-assisted living apartment complex alongside a fellowship of eighty-somethings, and they all take care of each other. Her neighbors are pushing one hundred years old. They play cards, garden, go to movies, do Bible study, serve each other, visit each other in the hospital, love, grow … live.

As we sat and visited with her, the nurse administrator came in to assess her, as she had just moved over from the surgery center to the rehab facility. She did a quick Q and A with her, my dad, and my aunt, assessing how the surgery had gone and her transition, as she was getting comfortable in her new location. I had taken my R-O-W-D-Y (yes, I'm saying it like a cheerleader) kiddos out to the hallway so that they could chat in peace, but I was only an earshot away from what they were discussing. This is what I heard.

Nurse Admin.: Ms. Jean, what would you say your goals are while you are here?

Grammy (said as blunt and confident as you could say something): Well, to walk out of here normal.

Nurse Admin. (snickering, but with kindness): Well, what might some *other* goals be?

Then my mind went spinning. I didn't hear exactly what my grandmother's response was, but I know she was undeterred in her goal to walk out of that rehab facility normally. To the defense of the nurse admin., she was simply doing her job, but her tone seemed discouraging. What she didn't know was that Ms. Jean has never been one to back down from limitations or challenges. My grandmother walked out of there on her own two feet with only the use of a walker or cane for balance and support. She'll continue to fight as hard as she can to walk on her own terms—without a single prop.

There is a spiritual lesson there for us. What would we say in the same situation if instead of a physical limitation, we were overcoming a spiritual one? What might our response be if asked, "What are your goals while you are here?"

Would we be so bold as to say, "To walk out of here healed and whole and full to the brim with Christ"?

How would we respond when someone replied in unbelief, "Well, what might some *other* goals be?" clearly indicating that being healed, whole, and full to the brim in Christ was unattainable.

I'd like to suggest otherwise with the story of Jacob. Long story short, he totally wrecks his life in an attempt to take something that wasn't his. He convinces his father to bless him with a birthright that didn't belong to him. He steals his brother, Esau's, birthright and then lives the rest of his days in fear of the repercussions of that decision.

He spends a majority of life manipulating to have and to ultimately lust for more. But what you manipulate to have you can never maintain or keep.

Jacob comes to a place of surrender with God. He wants to leave his past behind him and step into the future a different man. He wants to establish roots and be planted. He wants to stop running and start being. But he wants God's blessing to do it. We pick up the story there.

> And Jacob was left alone. And a man wrestled with him until the breaking of the day. When the man saw that he did not prevail against Jacob, he touched his hip socket, and Jacob's hip was put out of joint as he wrestled with him. Then he said, "Let me go, for the day has broken." But Jacob said, "I will not let you go unless you bless me." And he said to him, "What is your name?" And he said, "Jacob" Then he said, "Your name shall no longer be called Jacob, but Israel, for you have striven with God and with men and have prevailed." Then Jacob asked him, "Please tell me your name," But he said, "Why is it that you ask my name?" And there he blessed him. So Jacob called the name of the place Peniel, saying, "For I have seen God face to face, and yet my life has been delivered. (Genesis 32:24-30)[90]

I love how the study text of my English Standard breaks down verses 25-28.

> Jacob's injury highlights not only the strength of his opponent but also his own resolve to prevail. Jacob's determination to be blessed is demonstrated by his

reluctance to release his opponent, even when his hip is dislocated. From the context, "Israel" is probably to be understood as meaning "he strives with God." The renaming of Jacob brings to a climax a lifetime of struggling with others. Through all this, Jacob has finally come to realize the importance of being blessed by God.[91]

What are you trying to overcome? Spiritually speaking, what are your goals in life? What obstacle stares you in the face every day and snickers back, saying, "Well, you're not going to be able to overcome *that* struggle ... what are some *other* ... easier spiritual goals you can attain?"

One of the Scriptures I speak over my daughters every night is the second half of Judges 5:21, when the prophetess Deborah is proclaiming Victory as well as claiming the need for additional strength to overcome even more. I simply replace "my" with "Ainsley's and Shelby's souls": "March on my soul with might!" (Judges 5:21).[92]

It's going to take might to overcome what holds us back from living out a full and complete life in Christ. It takes might to hang onto Jesus. It takes might, resolve, and determination to be stayed with Christ. It takes might to believe Him at His word when everything is "snickering" back. You have to march on with might to obtain a healed and whole life in Christ.

> But we are not of those who shrink back and are destroyed, but of those who have faith and preserve their souls. (Hebrews 10:39)[93]

You can't shrink back and win. You have to advance and fight. The Lord, the ultimate Warrior, didn't shrink back to save you, and He won't shrink back to train you.

> Blessed be God, my mountain, who trains me to fight fair and well. He's the bedrock on which I stand, the castle in which I live, my rescuing knight, The high crag where I run for dear life, while he lays my enemies low. (Psalm 144:1-2)[94]

Advance with might in your faith. Advance with might in your desire to be healed, whole, and full to the brim with God. Don't stop short just because someone or something tilts its head and attempts to convince you your goal is too lofty.

> Let us hold fast the confession of our hope without wavering, for he who promised is faithful. (Hebrews 10:23)[95]

You might not be without a limp. Every spiritual warrior I admire has absorbed the blow of life and taken a fair amount of bullets. We all have the scars of struggle, but I've heard it said the best leaders walk with a limp.

Becoming all glorious within is risky, but it's worth it. We're too far gone to go back now. Let's choose to trust the words of James: "But if any of you, lacks wisdom, let him [her] ask of God, who gives to all generously and without reproach, and it will be given him [her]. But let him [her] ask in faith without any doubting"[96] (James 1:5-6). As your relationship with God gets more vertical and you start to live

by faith, be courageous. You are not alone. As a daughter of the King, I want all of God, and I am pressed within my spirit with believing there is a sweet fellowship of sisters that want the same thing. We just need to start standing together.

Praise God for all that you do and all that you are for the King. He has created you so special, and He is well pleased when you offer your gifts back to Him. He is an intimate Savior that has adorned you with a glorious life. Sometimes we just need to step back and see it the way He sees it. Worship God as He exposes all the ways He has gifted you and then feel His pleasure as you give it back to Him.

> In him, we have obtained an inheritance, having been predestined according to the purpose of him who works all things according to the counsel of his will, so that we who were the first to hope in Christ might be to the praise of his glory. (Ephesians 1:11-12).[97]

Stop performing. Stop looking at the pink dress out of the corner of your eye. What color has the Lord chosen to adorn you with? He went to great lengths to select the perfectly woven tapestry of your life. Start looking intently at that; I promise it will showcase itself to your heart and soul as the most glorious garment you have ever seen.

Our desires will fuel the search for the life we want so desperately. The perfected desire of reaching wholeheartedly toward Christ will deliver us from committing soul depravation on the altar of barely getting by. Don't settle for that. Allow Christ to fine-tune your desires, so you are

met with his exact plan for becoming all glorious within. Be blown away by God's wisdom and revelations of how much He can do with just one surrendered life. Be challenged to not just recognize the King as a part of your life, looking at Him with a sideways glance every now and again. Look full into His face, and see what He wants you to see about your life and the experiences He has so carefully orchestrated to bring you healing and great hope.

As I type these words, my heart is tender, remembering the fourth-grade girl who stood in the hallway of her elementary school and had a desire to be worthy. I thought it was pink that was the worthy color, but as the King watched me and knew the life that He had for me, He knew the small desire of pink would be exploded by the grandeur of the color gold. I am so glad that according to the fulfillment of prophetic promises in my life, God wanted this daughter to be adorned with the extravagance of the color gold. And most important, I'm glad I decided to ask and then listen to what the King had for me.

What does the King of Kings have for you? Have you asked Him?

Gaps

When I was in college, I had the rich—and honestly unexpected—opportunity to travel to Europe to visit two of my best friends who had decided to study abroad for a semester. It was one of those spring break trips that I still pinch myself when I think about taking.

Heartfelt memories flood my mind when I reminisce about that trip. The overwhelming emotions we all had as we stepped out of the Gatwick Airport onto the streets of London, and the powerful presence of those buildings etched with history were awesome. We were awestruck by the great energy of the city, the ambiance found in the museums, the cobbled streets, and the richness of a culture that has stood for thousands of years.

I remember funny moments, too. Traveling to Scotland on a bus for six hours and based on my overwhelming good luck, I was sick the entire time. Memorable to say the least. Once in Scotland, we nearly froze and had to wear, literally, every piece of clothing from our suitcases to stay warm in our hostile that night. Great pics! The pink curtains

combined with the red and blue Scottish plaid decorations of that hostile were classic, too; I'm seriously considering doing our next baby room with that look in mind. Lights out in London is no joke. And how could we forget the bus ride to the airport in the middle of the night in the wall of rain, with the bus racing at a cool 100 mph, all the while "enjoying" the aroma of the hairy-toed shoeless man eating food laced with curry the entire ride. Memorable. It's truly a miracle we made it. I can say I have never been happier to get somewhere stationary in my entire life.

The memory that stuck with me the most was a simple moment in our every day as we took the rail, the underground subway system. As you waited, the rail would come racing through the tunnel, make an abrupt stop, the doors would open, and before you could take a step through the doors, a man's voice would come over the loud speaker and say, "Mind the gap." I would die laughing. Why, you might ask? Because the "gap" he was talking about between the deck and the rail doors was either massive or so slight the warning seemed ridiculous. It was so very obvious that you had to "mind the gap" and step across onto the rail. Obviously, that was not the case, and somewhere down the line, someone forgot to mind and tumbled right into the gap. But it was and still is hilarious to me. We probably found a million reasons on that trip to reuse that phrase.

There are just as many holes in our lives, and if we aren't careful to "mind the gaps," we could fall right between the platform we're standing on and the rail that has the capability to take us to our next "God-sized promise." It's

no joke. Life is stinkin' hard, and if it isn't, quite honestly, you're probably not breathing.

I have a precious life with all sorts of beloved blessings. But if you think for one minute my life is worry or problem free, your bubble is about to bust. It's not. At this point, I'm taking risks that challenge every part of my life, and God is asking me to step where there is little to no light to illuminate the path. I have times when I feel uninspired to start the day or share a thought. I have relationship struggles that tear at my heartstrings, I have worries; I have major doubts at times of God's will and God's purposes, and if I don't mind the gap, I can throw off all sorts of Jesus and just fall right into the gap of despair. I can lose God's vision for my life. The temptation to be reckless and reject a life of faith and lose heart is all too present.[98]

I'm reminded of the scripture in 2 Corinthians 10:5. It really is so very crucial to living a gloriously full life as a daughter of the King.

> We are DESTROYING speculations and EVERY lofty thing raised up against the knowledge of God, and we are taking EVERY THOUGHT captive to the obedience to Christ. [99]

That's not going to come easily, and if you read it closely, it is full of action verbs. That means it doesn't conclude; it is an ongoing action. If we live skimming over the warning of 2 Corinthians 10:5, we give way to an opportunity for the Enemy to blind us and shift our focus just enough to where one day, what was a small gap becomes a massive

chasm between us and God, and we fall right in. No matter how spiritual you might have become, you have to have a warning. There is no arrival this side of Heaven. Someone, something, some circumstance, some perceived failure, some struggle, some message, some e-mail, some unclear communication will try to create a gap between you, the Love of your Father, and the life of promise He is taking you to if you leave it unsubmitted and uncaptivated.

In warfare, taking someone or something captive takes strength; you have to have a strategy to overcome the Enemy. Keeping our focus intently on Jesus is our strategy to minding the gap.

Think of it like a deep, loving Jesus voice coming over the intercom of your life every day and reminding you, "Mind the gap, Cari." Be looking for Jesus, and take *every* thought, project, situation, dream, job, relationship, emotion, and role and make your heart obey His will. Mind the gap by pushing God's love to come to the front of your marriage, your job security, your financial mistakes, your uncertain future, your health crisis, your hopes and dreams. Mind the gap by pushing God's love to the front of the lost affection you desire, your addictions, your hardened heart of sin, your fear, your worry, your regrets, your doubt, your church, your worship, your friends, your kids, your insecurity, your everything.

> Search me, O God and know my heart! Try me and know my thoughts! And see if there be any grievous way in me, and lead me in the way everlasting!" (Psalm 139:23-24)[100]

In the last several chapters, we have cultivated numerous things that prevent us from living a full life in Christ. We have looked intently at the dark areas of our lives that threaten to overtake our hearts. We have surrendered control, humbled ourselves, and made a decision to listen in on what and who God says we are. It's good to stir up the pot, but you have to make sure you are in the midst of making something. Nurturing passion and zeal for Christ is a good thing, but we can't stop there. We have to fill in all the gaps of life with tangible goals. We need action steps to produce a fruit from the passion we have as daughters of the King. So our next step in the journey of becoming all glorious within is to mind the gaps of all those things that we dug up. We have to fill it with something; we just need to make sure we fill it with Jesus. But it won't be easy.

I cannot emphasize enough the importance of keeping the vision of becoming all glorious within at the forefront of your mind and heart as you walk in life. At this point, I want to encourage you to write down your mission statement. Jot down what your focus is. Who are you called to be as a daughter of God? Who are you becoming in the process? I write important life-changing statements in the front of my Bible. My mission statement is in the Bible I used for fifteen years, and I jotted it down again the day I got a new Bible, which I have been using for almost four years now. I have to keep that statement of faith and vision at the front of anything I am doing. Keeping that vision alive and growing is crucial to maintaining a passionate relationship with God.

You are the only one who can make the choice to change and become all glorious within.

You are the only one that can *decide*, beyond whatever might be pushing up against it, that you will mind the gaps of your life with the fullness of God's Truth. Don't go halfway in, ladies. Go all in. Don't shrink back in fear and start to justify sin or laziness. Grow up in your faith, and to use a good cowboy expression, "Take the bull by the horns!" Minding the gaps of your life, becoming all glorious within, and living a full and abundant life are not for the faint of heart. It is going to take guts to stretch toward a gloriously beautiful life. Become an heiress to the Throne who is getting serious about her faith and her relationship with the Lord. Resolve heart and soul that nothing has the power to separate you from that vision.

Growing up as a coach's daughter, I was in my dad's baseball office and locker room a lot. There was a slogan my dad always used that I'll never forget. I'm still drawing inspiration from it today: "Ya gotta believe!"

It really is that simple, ladies. If you want the prize of a glorious life, you gotta believe it's possible. Your faith in a capable God has to be determined, resolved. Even when every single fiber in your being tries to stand up against that commitment, you have to drive home the vision. Burn it deep on your heart, say it over and over and over and over again, because the winds promise to blow, the rains are guaranteed to fall, and waves will rise and try with all their might to crash your soul in to oblivion.

In the Special Forces realm of the US military, Marine Recon school is the elite. The equivalent to Navy Seals, Army Rangers, and so on, the Recon regimen is daunting. The irony of "letting perseverance have its perfect work" is never seen more than in this arena. After four months of rigorous training, roughly one fifth of the class remains. The "hell week," no sleep, nonstop onslaught for seventy-two hours finishes with "the walk," a three-mile stretch at dawn, as weary warriors endure constant tear gas while carrying two hundred pound dummies over their backs. Everything is emptied. They have no choice but to give over everything. In the midst of tear gas and open gunfire, even control over their own bodies is forfeited. But the greatest reward is that there is no transition between strain and success. As the soldiers ascend the last hill of the walk, hundreds of Recon veterans line the down side of the hill, ready to congratulate the exhausted soldiers. It is finished. They accomplished it. As excited as those who endured, now transformed in an instant, the power of the mind, heart, and emotions of "fallen" teammates is the greater story. After thirteen weeks, six days, and literally less than one hundred to three hundred yards from the top of the hill, teammates see their friends quit. Whether it be an inner vow that was made late, lack of focus on the prize, or an overwhelming desire to stop the pain, some would still trade "stop" for "you made it." That is why minding the gap is a critical, life-changing, action step toward glorious living. Are you stopping short, or are you resolved to see it through?

Write the vision; make it plain on tablets, so he may run who reads it! (Habakkuk 2:2)[101]

We have become obsessed with encouraging my youngest daughter to take her first step. Even though we know she will more than likely fall down as soon as she does, we are still trying to give her the confidence to launch out and walk. That first step is an indication of growth and development. If she doesn't take a first step, we have problems. Not risking learning to walk means her development is delayed. Even though we know she will fall and may even fall hard, we encourage this first step. She might cry. She might even get hurt. More than likely, the first couple of steps she takes will prove wobbly and awkward. We almost encourage the falling, because in the falling, she will learn what will help her stay upright and walk. There is also a measure of trust involved. When she reaches out to take a step, it is important she believes we will catch her if she starts to fall. By taking a risk to use new muscles, she will learn what strengths to depend on. She will start to distribute her weight properly so that she can stand. Then one day, she will surpass walking altogether and will run.

God is obsessed with watching you grow and develop in your faith. Trust-filled love is what pleases His heart. "And without faith it is impossible to please him, for whoever would draw near to God must believe that he exists and that he rewards those who seek him" (Hebrews 11:6).[102] As you step out to new and unfamiliar territory with the Lord, your faith muscle will grow. You might even fall as you go, but falling only means learning. Your past has the potential

to propel you into a faith-filled future if you will let it. Or you could risk a step, get scared, fall, and never risk again. What agony in life to know your heart would never move or be moved. Taking a step in life for anything can be scary. But to me, not taking one is even more frightening. God's arms promise to catch you if you start to fall. God's power promises to perfect our weaknesses. God's wisdom and revelation promise to come if we ask. God promises to part the waters and let us walk through on dry ground. Our only responsibility is to risk stepping. "The steps of a man are established by the Lord, when he delights in his way; though he fall, he shall not be cast headlong, for the Lord upholds his hand" (Psalm 37:23-24). [103]

What's your "You gotta believe" statement? Maybe it's better said, what's your gut check statement? In the battle we face in this generation of being a believer, we have to have a go-to-gut-check statement. What's going to get us up and out of our seat and sticking with it? What's going to arise in our soul enough times that we finally make the change we want to make? It has to be personal. Get alone with God and lay everything down. Absolutely everything. "Undress yourself morally before God of everything that might be a possession until you are a mere conscious human being and then give God that." [104] Release yourself of performance pressure or expectation, and abandon yourself to Jesus. You may very well be one hundred yards from the finish.

VOICE

The 2011 Oscar season was surrounded in the glory of *The King's Speech.*[105] The Best Picture winner was indeed worthy of that praise and is genius in its message. The true story centers on "Bertie," King George VI of Britain, who reluctantly accepts the throne after his older, cavalier brother wishes it away. The main issue is that Bertie has a severe stutter that has masked his influence and strength in a lifelong fog of insecurity and self-doubt. Whether it be outside influences such as parents, friends, or contemporaries, Bertie's biggest enemy is himself. Quite literally, his perceived control over his "issue" steals his true voice, his true identity. He is escalated to full power and commissioned as the king. The movie surrounds a time in history when kings were more for show that function, and Bertie's stutter could very well have stayed hidden during the duration of his reign. However, as history rolls on, radio and recordable sound are invented, and kings are now required to give speeches and lead the people with inspirational motivation. Bertie the king will now be required to speak publicly, and the

public doesn't respond to a stuttering king. During the final scene in the movie, Bertie the king is called to give his first wartime speech during a pivotal time in the history of the world. He needs to speak with passion, confidence, power, authority—not the weakness of a stutter. Standing before the microphone, he is told that the red light will blink three times to warn him recording is about to begin and then he will be live. He now faces more than just a live microphone; he is approaching every fear in his life head-on as the red light blinks.

The red light starts blinking. One. Two. Three.

Go ...

When his nation needed a leader ...

When his people needed a voice ...

He could do it, if he wasn't governed by fear ...

During the King's first wartime speech, his therapist calmed his fears by reminding him to just forget everything else and say it to him. But when he said it to him, he said it to the world in one of the most pivotal times in history.

Your control and obsession with perfection have the potential to suffocate the effectiveness of your voice as a daughter of the King and, ultimately, silence the voice that is spoken on behalf of the nation of Christ.

> I have seen a limit to all perfection, but your commandment is exceedingly broad. (Psalm 119:96)[106]

We live in a perfectionist society. We are all our own PR reps. If you have a Facebook, you have a publicist for your life. Our family Christmas letters express the perfection

of a year in review. Truth be told, the majority of us are probably writing those letters in our pj's and they would be a little more authentic if we included, "I'm tired. I didn't put makeup on until 4 p.m., and when my husband got home at 5 p.m., I griped him out, and every one of my children are touching me! Merry Christmas."

As women, we struggle with the lust of perfection. We want to be perfect moms, wives, working professionals, friends, daughters—we want to do and have it all perfected. But according to God's Word, perfection is limited. So all our attempts to present a perfect life fall flat and end up limiting us.

During the first therapy session with the King, the therapist asks Bernie to read a stanza of Shakespeare. Pinned up with frustration and the limitation of his stutter, the King suffers through a few lines with excruciating effort. Overtaken with the embarrassment and frustration he feels rising over the grandeur and respect of him as the King, he shouts his surrender in anger and quits. But before the therapist allows him to leave, he asks him to try it one more time into the phonograph while listening to extremely loud Beethoven. The King is unsure and exasperated at the thought of giving the already failed attempt at reading aloud another chance. However, he puts on the earphones and reads into the phonograph. As an audience, all we hear is the loud nature of the classical music playing in the background. We see the King's mouth moving, but don't hear him utter a word. He finishes the stanza, rips off the earphones, and tears out of the therapist's office. But not before the therapist

can send him away with the recording of him reading. After several frustrations and failed attempts to speak publicly, the King has come to a place of surrender. As he is in an attitude of pensive reflection over his limitations one evening, he throws the recording on the record player to listen to what he thinks is yet another agonizing speaking defeat. But what he hears is the eloquence of a king reciting Shakespeare. Perfectly.

No matter what we have discussed up to this point in this binding called a book, this is the one point you need to hear aloud in your ears. God wants to sing louder than the stuttered nature of our own voice. He wants us to lose control, throw back our heads, and just let go and let Him. He wants to sing over us and sing Victory for us.

> The Lord your God is in your midst, a mighty one who will save; he will rejoice over you with gladness; he will quiet you by his love; he will exult over you with LOUD singing. (Zephaniah 3:17)[107]

King George spoke perfectly when the loud music in his ears muffled his awareness of his own inability. When he was forced to relinquish control by not being able to hear his greatest limitation, his voice resounded with eloquence and ease and became his greatest asset.

Are you doing the same thing?

As we live to seek the King and lay down the crowns of our flesh, let us be careful not to pick up the broken crown of perfection. The unperfected, unscripted moments of my life are the very moments God wants to be magnified the

most. And my control, my obsession with the perception of perfection of my life, steals my voice for His Kingdom as well as stealing Him the opportunity to *be* the voice.

We have to put ourselves in a submitted position to receive power. We cannot be our own Savior. Therefore, we cannot be in control. I know everything in your reality might scream the opposite. You can do the #doitallPTAmom plus #perfectSusieQhomemakerVictoriaSecrettrophywife, in addition to the #glassceilingbreakingworkingprofessional as well as the #chef, #nurse, #counselor, #administrator, #family publicist, #philanthropic, #banker, #minister. Whew! And the list could go on and on and on. I'm not saying we can't rock all those roles with power. I'm saying you can't do it on your own terms of limited perfection.

> I have seen a limit to all perfection, but your commandment is exceedingly broad. (Psalm 119:96)[108]

I think we can be tempted to assume the responsibility of perfecting our reality based on our own terms when changes to our lives start to arise. And believe me, becoming all glorious within will raise some changes that need to take place. Our temptation will be to change a few things and then overcontrol the rest. We think if we submit to be transformed in a few areas but control and perfect the other areas of our lives, it will increase our opportunities to be used by God, because, "I am at least better than I used to be." No. That is not how it happens. All we end up doing is hemming in ourselves and God and circling back to start at

square one again. We end up frustrated and unhealed. Our lust for perfection only limits us.

Only a few verses up in Psalms 119:32, we are reminded that God's ways actually broaden our perspectives. It is in that place of wholehearted surrender to God's ways and commandments as daughters that we actually are given a greater ability to perceive God's truth.

> I will run in the way of your commandments when
> you enlarge my heart! (Psalm 119:32)[109]

It generally plays out like this in our lives. There is a need—a problem to solve. We find a place where we need healing. We find sin in our lives. We might even come to a revelation of Jesus and greater understanding. We go to the Lord for help, surrender, peace, perspective, and so on in a high "mountaintop" moment. We are still living on the adrenaline of surrender. Submitting during that time is crucial. We go so far and then start offering our own perfected suggestions. We suffocate our own voice and His. As humans, we are generally far better givers than receivers. If we fully submit without any suggestions, we are completely out of control. Can't control how it will look, what He will do or make us do, and if it will fit into the perfected life we are trying to stockpile. We can't control receiving God's power, so we hem it in and offer ideas. We are fixers by nature. And what better to fix than our own lives.

> "I need oil," said an ancient monk, so he planted
> an olive sapling. "Lord," he prayed, "it needs

rain that its tender roots may drink and swell. Send gentle showers." And the Lord sent gentle showers. "Lord," prayed the monk, "my tree needs sun. Send sun, I pray thee." And the sun shone, gilding the dripping clouds. "Now frost, my Lord, to brace its tissues," cried the monk. And behold, the little tree stood sparkling with frost, but at evening it died.

Then the monk sought the cell of a brother monk, and told his strange experience. "I, too, planted a little tree," he said, "and see! It thrives well. But I entrust my tree to its God. He who made it knows better what it needs than a man like me. I laid no condition. I fixed not ways or means. 'Lord, send what it needs,' I prayed, 'storm or sunshine, wind, rain, or frost. Thou hast made it and Thou dost know.'"[110]

I love what Linda Dillow says before she tells the above story in the book *Calm My Anxious Heart*. "Contentment is accepting God's sovereign control over all of life's circumstances. It was humbling for me to have to say to God, 'I've tried to trust you, but too much of my own strength has been mixed with that trust.'"[111]

At this point in your journey with the King, you have to be comfortable settling into His lap and allow His able hands to take control of your life. All your life, even your healing and becoming all glorious within, has to rest comfortably in His hands as well as His power working through you. It all has to be so very situated.

How blessed are the people who are so situated.
How blessed are the people whose God is the Lord!
(Psalm 144:15)[112]

We can put no conditions on Christ as He re-creates Himself in and through our lives and we become all glorious within as His daughter. His ways might seem unorthodox and controversial. But He will require complete trust and full submission of our wills to create a life fully alive in Christ and a daughter with a life fully glorious from the inside out. Not for a short-term gain. We are talking inside out, long-term investment, lifestyle change. Not just while you are reading this book, only to get to the final page and abandon the principles. No, you have to decide deep within your marrow to allow the transformation process to belong to Him, because the changes will prove too hard to perfect in your own strength. All perfection is limited. You can't hope to adjust a few kinks in your spiritual life while you go through your next Bible study or attempt your next "fresh start" life of faith and live a gloriously beautiful life. Your efforts will prove frustrating. You have to decidedly come to a place of such surrender as a daughter that you trust your Father no matter how the path meanders toward you becoming all glorious within. With all that we've ventured to discover within the depths of our hearts as we are reaching a becoming as the daughters of the Most High King, this one truth has to resound louder than any other.

As a daughter of the King, I trust the measures He will take to infuse me with the tenacious strength I

will need to carry out my calling as a royal heir to the Throne of Grace.

Say it out loud. Look in the mirror. No, seriously go. Look in the mirror, and make a decision right now. Get down on your knees in faith and surrender your control, even the temptation to control your own healing. Put on those earphones and hear the loud song of the King rising above your own voice.

> My response is to get down on my knees before the Father, this magnificent Father who parcels out all heaven and earth. I ask him to **strength**en you by his Spirit—not a brute **strength** but a glorious inner **strength**—that Christ will live in you as you open the door and invite him in. And I ask him that with both feet planted firmly on love, you'll be able to take in with all followers of Jesus the extravagant dimensions of Christ's love. Reach out and experience the breadth! Test its length! Plumb the depths! Rise to the heights! Live full lives, full in the fullness of God. (Ephesians 3:14-19)[113]

As you pursue a glorious life, you will find there are hidden parts of your heart that make you capable of facing your calling as a daughter of the King. You have been given gifts, talents, and qualities that work in your favor and give you a platform as an heiress to the Throne of Grace. But if you are anything like me, once I get on a roll, I want the whole thing. I don't want to stop short of finishing the full race.

Several years ago, I ran a marathon. As we reached the end, people on the sidewalks started shouting, "You're almost there. It's pretty much done." We were at mile twenty-one. I remember saying to my running partner, "We aren't done! We still have 5.2 miles left, and I'm going to finish strong. If I tell myself I'm done now I'm going to be tempted to start walking." I was tired, but I had run too long to stop short. And believe me, when I saw that finish line on the horizon, I sprinted. I became some sort of raving animal and dead leg sprinted toward the finish line.

If you are interested in finishing strong, you will come to a place where your understanding, even enlightenment, will come to a screeching halt. You can make a choice to coast it in. You can stop 5.2 miles from the full throttle of a gloriously beautiful life and walk the rest of the way in. I could have decided to back off and walk across the finish line of that marathon. For Pete's sake, we'd been running for five hours! I was tired! But it made it much more memorable to run with everything left in my being toward that finish. Run with gusto across that finish line toward glorious living. Go further than you think you can go. And if you do choose to go farther, you will need a supernatural anointing of God's wisdom.

I love Psalm 92 and how the psalmist is singing for joy over all the Lord has done and how great He is, and yet he asks for a fresh anointing. It indicates that he isn't finished running. He's ready to see God do even more. He wants to sprint across that finish line.

For Thou, O Lord hast made me glad by what Thou
has done, I will sing for joy at the works of Thy hands.
How great are Thy works, O Lord! Thy thoughts are
very deep.

I have been anointed with fresh oil.

I will still yield fruit in old age. (Psalm 92:4-5, 10, 14)[114]

As daughters anointed to see God do even more
extravagant gestures of Victory in their lives, we have to
submit all control for perfection in order to finish strong.
We have to let the Author and Perfector of our faith and
lives do His job over and over and over again. We have to
submit to the proficient Hand of God to anoint our lives
with a continual fount of fresh oil.

King Solomon had gotten to this very place. He had
governed up to that moment with an enlightened, self-
serving kind of wisdom and done rather well. But now he
had reached a new place. He needed a fresh anointing to
finish strong.

And now, O Lord my God, you have made your
servant king in place of David my father, although
I am but a little child. I do not know how to go
out or come in. And your servant is in the midst of
your people whom you have chosen, a great people,
too many to be numbered or counted for multitude.
Give your servant therefore an understanding mind
to govern your people, that I my discern between
good and evil, for who is able to govern this your
great people?

It pleased the Lord that Solomon had asked this,
And God said to him, "Because you have asked this,
and have not asked for yourself long life or riches or
the life of your enemies, but have asked for yourself
understanding to discern what is right, behold I now
do according to your word. Behold, I give you a wise
and discerning mind, so that none like you has been
before you and none like you shall arise after you. I
give you also what you have not asked, both riches
and honor, so that no other king shall compare with
you, all your days. And if you will walk in my ways,
keeping my statues and my commandments, as your
father David walked, then I will lengthen your days.
(1 Kings 3:6-14)[115]

King Solomon had been called by God. He had been
given incredible responsibility as an heir to the throne. His
people needed a voice. He needed a supernatural dose of
empowerment, wisdom, and understanding. He had seen
incredible things done by the generation behind him.
Now it was his turn to step up to the microphone. He
had submitted to the Lord, but he was insecure in his own
abilities. He needed a louder voice than his.

The King is calling you to live gloriously as a daughter
of the King in this generation. To allow Him the blessing
of being the great giver in our lives is another step toward
glorious living. He has storehouses of favor to open up to
us; all we have to do is submit complete trust to Him.
We've come to the place of healing. We've come to a place
of worshipping the King. We're set free. We've become all
glorious within, and now the King is ready to use us as

daughters. Now is the time to, as Ephesians 6:13-14 says, "Therefore, take up the full armor of God, that you may be able to resist in the evil day and having done everything to stand firm, stand firm therefore." [116]

You are ready to stand firm. The days are evil, and the accuser of our souls is chattering away. He is unclear in his message, but he says it with great craftiness and perceived eloquence.

Going back to our movie *The King's Speech*, there is a scene where the King is sitting with his family, watching the current propaganda of Nazi Germany. A series of slides shows Hitler giving a very passionate speech to a sea of people. The King's daughter, Elizabeth, turns to her father and asks him what that man is saying. The King responds that he isn't sure, but whatever it is, he seems to be saying it rather well.

The Enemy plays for keeps. What a great example of the Enemy's descriptive character. He's talking to the next generation. His message is unclear, full of lies and exalted deceptions, but he is somehow saying it rather well. And what are we doing? We are sitting tucked away in the limited nature of our insecurities and waiting to have perfected lives to present as worthy voices on behalf of the Kingdom.

You've come to a crossroads. You can read these last lines, close this book, make a few faith life modifications, and live relatively happy in your own limited controlled reality.

Or you can read these last lines and make a decision. Just like the last scene of *The King's Speech*, you can stand

before the microphone, poised to inspire a generation. After three blinks, the little red light will turn off, and you will be on. You can decide to cross the line into the full measure of glorious living. You can turn up the volume of your earphones to the voice of the King so loud you can't hear your own voice, let alone be limited by your own shortcomings. You can press so closely into the sound of His voice that there is no difference between your voice and His. The direction has been given, and once that red light blinks, there is no more preparation or control. You're live, and you have a Word to speak.

I have some news for you ...

The nation of God is in need of a leader ...

God's people need a voice ...

You can do it. Don't be governed by fear ...

Forget everything else and say it, live it, and become it for the King ...

But when you say it to the King ...

You'll say it to the world.

The little red light is blinking in your life. One. Two. Three. Go and live a beautifully brave life of faith.

The King's daughter is all glorious within. (Psalm 45:13)[117]

ENDNOTES

[1] Psalm 16:5-6 ESV.
[2] Psalm 45:13 NAS.
[3] Psalm 127:4.
[4] John 10:10 NAS.
[5] Psalm 45:13 NAS.
[6] *String of Pearls* by Cari Trotter, 2004 story from String of Pearls Inc. Couture Designer for the Mini-Princess.
[7] Proverbs 31:25 The Message.
[8] Matthew 9:13-14 NAS.
[9] Psalm 37:4 NAS.
[10] Isaiah 61:10.
[11] Isaiah 52:1-2.
[12] Galatians 5:22-23 NIV.
[13] Isaiah 61:7 ESV.
[14] Isaiah 62:3-4a ESV.
[15] John 10:10 NAS.
[16] Luke 1:45 NAS.
[17] Ephesians 1:5-6 NAS.
[18] Isaiah 62:9-11 The Message.
[19] Psalms 45:13.
[20] Psalms 45:13 NAS.

21 John 1:16 ESV.

22 Ephesians 1:7 ESV.

23 Psalm 28:8 ESV.

24 Deuteronomy 23:3 ESV.

25 Ruth 1:4-5 ESV.

26 Ruth 1:16 ESV.

27 Ruth 4:10 ESV.

28 Matthew 1:17 ESV.

29 Cited from an e-mail to friends, with Kirsten's permission.

30 Ephesians 6:12 AMP.

31 Lamentations 2:19 NAS.

32 Psalm 25:16.

33 Psalm 24:7-9 ESV.

34 1 John 1:5-7 ESV.

35 1 Timothy 6:15-16 ESV.

36 Psalm 139:15-16 21st Century KJV.

37 Lauren Elise Memorial Foundation, www.ilovelauren.org.

38 Hope Link www.okchopelink.org.

39 Isaiah 61:1 NIV.

40 Romans 8:28 NIV.

41 Job 13:15 NIV.

42 Colossians 1:9-14 ESV.

43 1 Timothy 6:15-16 ESV.

44 John 16:33 NAS.

45 Buchanan, Mark. *The Rest of God*. Nashville, TN: Thomas Nelson, 2006.

46 2 Timothy 1:7 NAS.

47 Ephesians 5:14 ESV.

48 Judges 5:21 ESV.

49 Psalm 16:5-6, ESV with personal interpretation added.

50 2 Timothy 3:1-4 NAS.

51 2 Timothy 3:14-17 NAS.

52 Psalm 18:34-36 NAS.

53 Isaiah 58:8 ESV.

54 Ramsey, Dave. *The Total Money Makeover*. Nashville, TN: Thomas Nelson, 2009.

55 *Snow White*. Dir. J. Searle Dawley. Perf. Adriana Caselotti. Walt Disney Pictures, 1937. Film.

56 *Snow White*. Dir. J. Searle Dawley. Perf. Adriana Caselotti. Walt Disney Pictures, 1937. Film.

57 Proverbs 4:5-9 NAS.

58 Ephesians 5:17 ESV.

59 1 Timothy 4:12 ESV.

60 Isaiah 57:14 ESV.

61 Deuteronomy 30:11 ESV.

62 Matthew 5:13 ESV.

63 Luke 1:26-45 ESV.

64 1 Samuel 16:1-13 ESV.

65 Esther 2:1-20 ESV.

66 Genesis 21:1-6 ESV.

67 Genesis 6-9 ESV.

68 Lamentations 3:21 ESV.

69 Ezekiel 36:26 NAS.

70 Acts 26:18 NAS.

71 Ezekiel 36:35 ESV.

72 Gunter, Sylvia. *For the Family*.

73 John 1:14,16-17 NAS.

74 John 17:1-8, 10 ESV.

75 John 17:2 ESV.

76 John 17:17-19 ESV.

77 John 1:1 ESV.

78 John 15:4 ESV.

79 As previously posted on the online magazine *Destiny in Bloom*, www.destinyinbloom.com.

80 Chambers, Oswald. *My Utmost for His Highest.*

81 Isaiah 55:11 ESV.

82 Omartian, Stormie. *Praying Through the Deeper Issues in Marriage.*

83 The Tapestry Project, www.thetapestryproject.org.

84 Psalm 21:1-7 ESV, as described by author.

85 Psalm 16:5-6 ESV.

86 As previously posted on the online magazine *Destiny in Bloom*, www.destinyinbloom.com.

87 Kubiak, Shannon. *The Divine Dance: If the World Is Your Stage, Who Are You Dancing For.* Uhrichsville, Ohio: Barbour Publishing, 2003.

88 Psalm 139:13-14 ESV.

89 *Chariots of Fire.* Dir. Hugh Hudson. Perf. Ben Cross, Ian Charleson. Allied Stars, ltd. 1981. Film.

90 Genesis 32:24-30 ESV.

91 ESV Study Text on Genesis 32:24-30.

92 Judges 5:21 ESV.

93 Hebrews 10:39 ESV.

94 Psalm 144:1-2 The Message.

95 Hebrews 10:23 ESV.

96 James 1:5-6 NAS.

97 Ephesians 1:11-12 ESV.

98 As previously posted on the online magazine *Destiny in Bloom*, www.destinyinbloom.com.

99 2 Corinthians 10:5 NAS.

100 Psalm 139:23-24 ESV.

101 Habakkuk 2:2 ESV.

102 Hebrews 11:6 ESV.

103 Psalm 37:23-24 ESV.

104 Chambers, Oswald. *My Utmost for His Highest.*

105 *The King's Speech*. Dir. Tom Hooper. Perf. Colin Firth, Geoffrey Rush. Momentum Pictures, 2010. Film.

106 Psalm 119:96 ESV.

107 Zehaniah 3:17 ESV.

108 Psalm 119:96 ESV.

109 Psalm 119:32 ESV.

110 Psalm 144:15 NAS.

111 Ephesians 3:14-19 The Message.

112 Psalm 144:15 NAS.

113 Ephesians 3:14-19 The Message (emphasis added).

114 Psalm 92:4-5, 10, 14 ESV.

115 1 Kings 3:6-14 NAS.

116 Ephesians 6:13-14 NAS.

117 Psalm 45:13 NAS.

CPSIA information can be obtained at www.ICGtesting.com
Printed in the USA
LVOW062210080812

293482LV00001B/1/P